OXFORD, WORCESTER & WOLVERHAMPTON RAILWAY

THROUGH TIME

Stanley C. Jenkins

AMBERLEY PUBLISHING

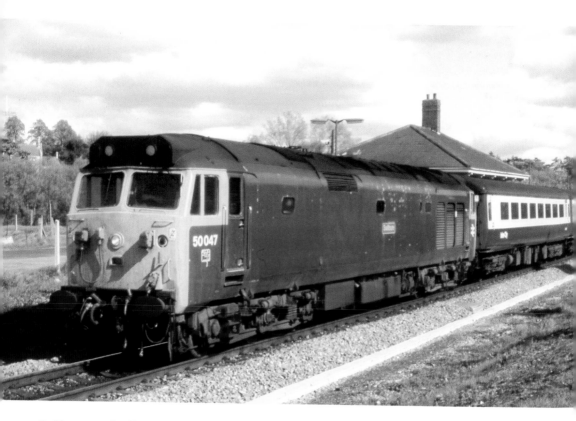

Swiftsure at Charlbury
English Electric class '50' diesel locomotive No. 50047 *Swiftsure* enters Charlbury station with a Paddington to Hereford express on 1 May 1982.

First published 2013

Amberley Publishing
The Hill, Stroud
Gloucestershire, GL5 4EP

www.amberley-books.com

Copyright © Stanley C. Jenkins, 2013

The right of Stanley C. Jenkins to be identified
as the Author of this work has been asserted in
accordance with the Copyrights, Designs and
Patents Act 1988.

ISBN 978 1 4456 1654 4 (PRINT)
ISBN 978 1 4456 1673 5 (EBOOK)

British Library Cataloguing in Publication Data.
A catalogue record for this book is available from
the British Library.

Typeset in 9.5pt on 12pt Celeste.
Typesetting by Amberley Publishing.
Printed in the UK.

Introduction

The Oxford, Worcester & Wolverhampton Railway was promoted in the 1840s as a rail link between Oxford and Wolverhampton via Moreton-in-Marsh and Worcester. The OW&WR was initially seen as a member of the Great Western 'family', and with Isambard Kingdom Brunel (1806–59) as its engineer, it was envisaged that this new main line would be constructed as a 7-foot broad-gauge route.

The OW&WR Bill was sent up to Parliament in November 1844, and with Great Western support the OW&WR Act received the Royal Assent on 4 August 1845. The company was thereby empowered to build a railway from the Oxford branch of the GWR to the Grand Junction Railway station at Wolverhampton, with branches to the River Severn at Diglis Basin, to the Birmingham & Gloucester Railway at Stoke Prior, from Amblecote to Stourbridge, and from Brettel Lane to Kingswinford.

The Act stipulated that the OW&WR was to be 'constructed and completed in all respects to the satisfaction of the engineer for the time being to the Great Western Railway', and be 'formed of such a gauge, and according to such mode of construction as will admit of the same being worked continuously with the said Great Western Railway'. The Great Western was empowered to complete the 89-mile line, should the OW&WR fail to do so, and six of the sixteen OW&WR directors were to be GWR nominees.

Construction was soon underway, and in 1846 Brunel reported that three tunnel contracts had been started, while work had commenced in the Worcester area. By the beginning of 1847, over 2,800 navvies were toiling throughout the entire length of the OW&WR. Unfortunately, progress was impeded by wet weather and a series of failed harvests, which brought an abrupt end to the railway construction boom.

The Oxford, Worcester & Wolverhampton line was still, as yet, unfinished, although in September 1849 the OW&WR shareholders were told that, from Tipton to Dudley, the line was 'practically completed' and ready to receive the permanent way. From Dudley to Stourbridge, a distance of around 4 miles, very little had been accomplished, but the line was 'nearly ready' between Stourbridge, Worcester and Pershore. South of Pershore, the works were in a 'forward state' as far as Shipton-under-Wychwood, but the southernmost extremity of the line was the least advanced.

The first section of the OW&WR was opened on 5 October 1850, when a single line was brought into use between Abbotswood Junction on the Midland line and the unfinished station at Worcester Shrub Hill. On 18 February 1851 a further section of line was opened from Worcester to Stoke Works Junction, but with Campden Tunnel still unfinished there seemed little possibility of an early opening of the main line to Oxford.

The Oxford, Worcester & Wolverhampton directors had appealed to the GWR for help, but the latter company was unwilling to assist its former protégé. However, the Great Western was pressing ahead with the completion of an alternative main line between Banbury, Birmingham and Wolverhampton. The OW&WR directors, viewing this as a monstrous breach of faith, broke away from the GWR and signed a new agreement with the rival London & North Western Railway, which opened the way for completion of the Oxford, Worcester & Wolverhampton line as a standard-gauge route, with trains running through to London Euston via the Yarnton Loop and the L&NWR line to Bletchley.

This change of allegiance placed Brunel in an unenviable position and on 17 March 1852 the directors accepted his resignation, while regretting that 'circumstances should have occurred which, in Mr Brunel's mind' had rendered such a service necessary. However, the OW&WR 'thankfully accepted his offer to render assistance to his successor', and asked Brunel to furnish John Fowler, their new engineer, 'with all necessary information and documents which he may require'.

Meanwhile, the OW&WR was being opened in stages, and on 1 May 1852 a major section of the route was ceremonially opened between Stourbridge and Evesham. In August 1852, the directors asked Fowler to 'furnish plans and estimates of stations and station houses' for the Evesham to Oxford section of the line, and this major portion was ceremonially opened on Saturday 2 April 1853. Public services began on Saturday 4 June 1853, when the route was opened throughout to Oxford, with intermediate stations at Handborough, Charlbury, Ascott, Shipton, Adlestrop, Moreton, Blockley, Campden, Honeybourne, Evesham, Fladbury and Pershore.

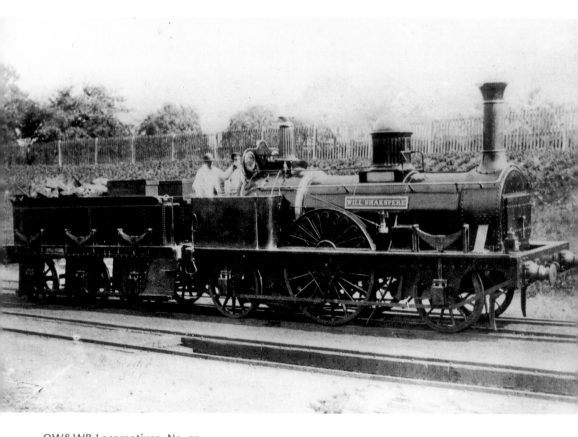

OW&WR Locomotives: No. 51
Many of the OW&WR locomotives were obtained from Messrs E. B. Wilson of Leeds, the 'pride of the line' being single-wheeler No. 51 *Will Shakspere*, built in 1856, and seen here as GWR No. 208.

The West Midland Railway

Having broken away from the GWR, the Oxford, Worcester & Wolverhampton Railway inevitably moved closer to the London & North Western company – although it was also willing to enter into joint ventures with smaller undertakings such as the Newport, Abergavenny & Hereford Railway. This Welsh border line had originally been worked by the L&NWR, but the arrangement was terminated following a disagreement about through traffic. Having freed itself from the North Western, the Abergavenny company had to find a new eastern outlet for its South Wales coal traffic, and in 1858 the NA&HR joined forces with the OW&WR in order to complete the Worcester & Hereford Railway, which had been authorised in 1853.

Although the NA&HR was prepared to support the Worcester & Hereford scheme, the Abergavenny company was a small railway with few capital resources. The OW&WR, on the other hand, was comparatively well-off by the late 1850s, and the new partnership between the NA&HR and OW&WR companies was in effect an OW&WR takeover.

It was agreed that the two companies would be combined to form 'The West Midland Railway', and these arrangements were formalised by Act of Parliament on 1 July 1860. By this Act, the Newport, Abergavenny & Hereford and the Worcester & Hereford railway companies were dissolved and merged with the Oxford, Worcester & Wolverhampton Railway under its new name. Sixteen OW&WR directors were joined by five from the NA&HR and two from the W&HR to form an enlarged board, based at Worcester. The then chairman of the OW&WR, William Fenton, became chairman of the West Midland Railway, while W. P. Price, the former chairman of the NA&HR, became the deputy chairman of the West Midland Railway.

A few months later, in a surprise move, it was decided that the West Midland company would be leased to the Great Western, and in 1863 the West Midland and Great Western companies were fully and finally amalgamated. Trains ceased running through to Euston via the L&NWR route, and Paddington became the London terminus for Worcester expresses – a situation that has remained in effect until the present day.

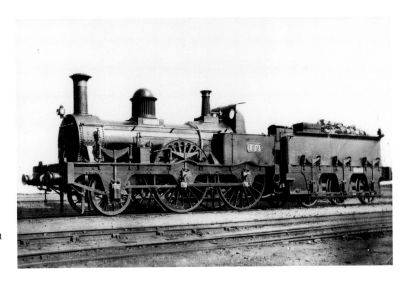

OW&WR
Locomotives: No. 41
Wilson large-wheeled
2-4-0 locomotive No. 41
was built in 1855 and
became GWR No. 189.

The Beeching Years

For the next eighty-five years, the former OW&WR system was worked as an integral part of the GWR. Trains continued to convey through portions for Wolverhampton although, in the fullness of time, Hereford replaced Wolverhampton as the western terminus of the 'Cotswold line'.

The nationalisation of Britain's railways on 1 January 1948 made little difference to the OW&WR route, which continued to operate much as it had done during the Great Western era. However, from the mid-1950s onwards, the ruling political party adopted an increasingly hostile attitude towards the state-owned railways, and in February 1963 this hostility culminated in the publication of the Beeching Report, which recommended a savage closure programme.

As far as the OW&WR was concerned, the Beeching proposals envisaged the deletion of every local station between Oxford and Worcester, leaving Charlbury, Moreton-in-Marsh and Evesham as 'railheads' for the Cotswold area. In the event, a change of government in 1964 saved many of the intermediate stations, insofar as Labour Transport Minister Tom Fraser stipulated that local services should be retained between Oxford and Moreton-in-Marsh.

The modified closure plan came into effect from Monday 3 January 1966, which meant that Saturday 1 January was the final day of operation for the doomed stations north of Moreton-in-Marsh. On that same day, most of the stopping places south of Moreton were demoted to 'unstaffed halt' status. Further downgrading took place in 1971, when the line was reduced to single track between Wolvercot Junction and Norton Junction, leaving a crossing loop at Evesham and a residual section of double track between Ascott-under-Wychwood and Moreton-in-Marsh.

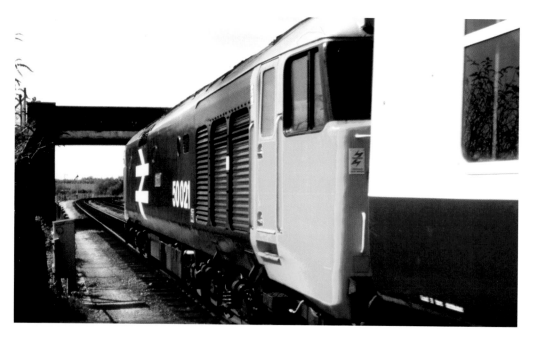

Rodney at Evesham
Class '50' locomotive No. 50021 *Rodney* leaves Evesham with a down train on 1 May 1982.

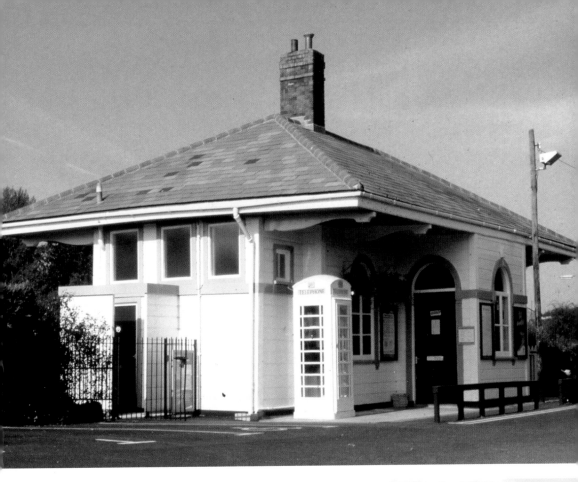

Recent History

Notwithstanding the negative effects of the Beeching Plan, the 'Cotswold line' prospered throughout the 1980s and 1990s, when large numbers of people (including the author) began to commute to and from Paddington on a daily basis, using Charlbury, Kingham and the remaining stations as convenient 'park-and-ride' points. Traffic became so healthy that, in 2008, it was agreed that 20 miles of double track would be reinstated, and this work was completed in 2011.

The illustrations show two of the surviving stations on the former OW&WR route: Charlbury, with its well-preserved Brunelian station building, features in the upper photograph, which was taken in September 1997, while the view to the right depicts a class '117' diesel multiple unit at Finstock Halt on 1 May 1982. Both of these photographs were taken by Mike Marr.

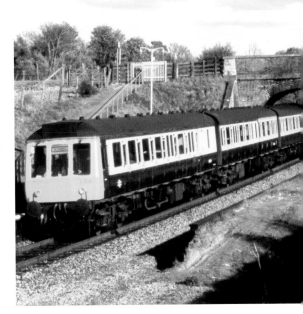

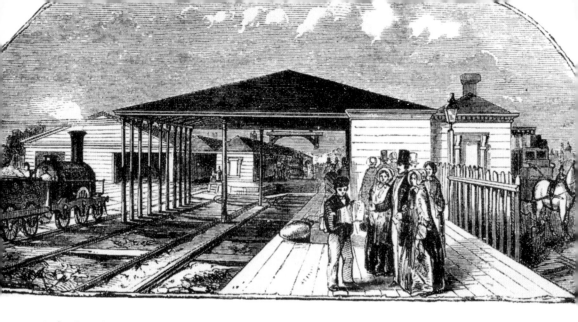

Oxford Station

The GWR opened its line from Didcot to Oxford on 12 June 1844, the first station being a terminus in St Aldate's, which is shown in the upper picture. The present station was brought into use on 1 October 1852, when the Oxford to Birmingham main line was opened throughout. This second station had a quadruple-track layout, with wooden station buildings on both sides. The lower picture shows part of the station during the Edwardian era, probably around 1908.

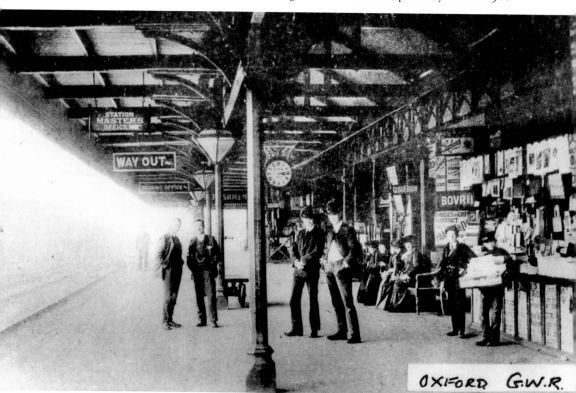

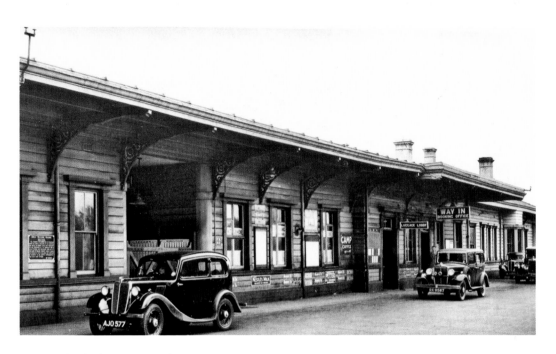

Oxford: The GWR Station

The station boasted a range of accommodation, including booking facilities, waiting rooms, refreshment rooms, parcel facilities, mess rooms and toilets. The up and down platforms were linked by an underline subway, and lengthy canopies were provided on both sides. The upper picture shows the up-side station buildings around 1930. Oxford station was rebuilt in 1970–71, the new buildings being of purely utilitarian appearance. However, following a further reconstruction scheme, the present-day station, which is shown below, was brought into use in 1990.

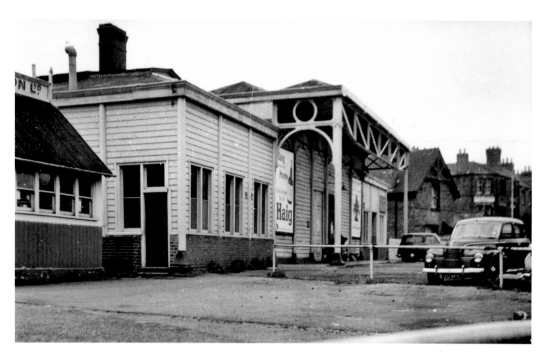

Oxford: The London & North Western Terminus

Opened in 1851, Oxford Rewley Road station was the terminus of the London & North Western line from Bletchley. It was used by OW&WR freight trains and by some passenger services from 1854 until 1861 – although most passenger workings continued to use the GWR station. Rewley Road was closed in 1952, and its site is now occupied by the Said Business School and modern housing developments, some of which can be seen in this recent view of the station approach.

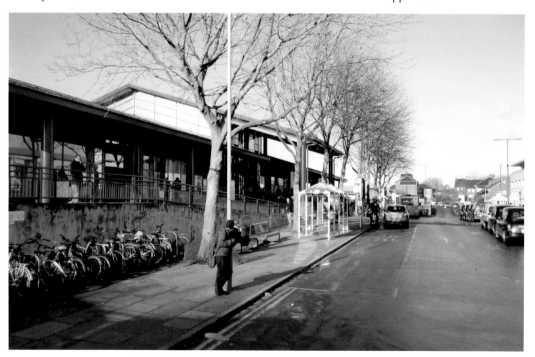

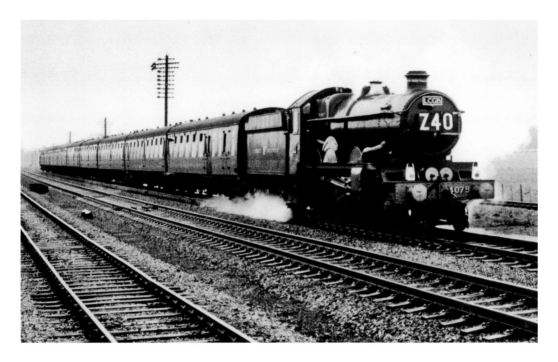

Oxford: Port Meadow

Leaving Oxford, down trains run northwards along the multiple-tracked Great Western main line, with the verdant expanse of Port Meadow visible to the left. The upper photograph shows 'Castle' class locomotive No. 4079 *Pendennis Castle* speeding across Port Meadow with a Locomotive Club of Great Britain special on 20 November January 1965, while the colour view, taken in December 2012, shows a four-car 'Voyager' unit heading northwards along the same section of track.

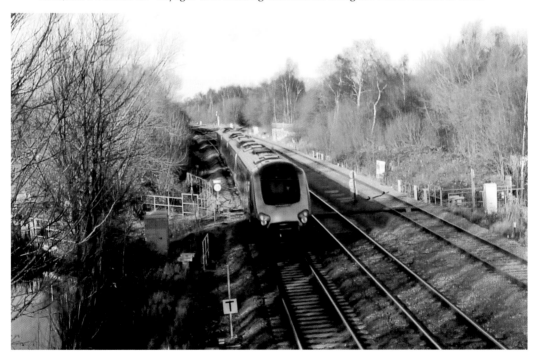

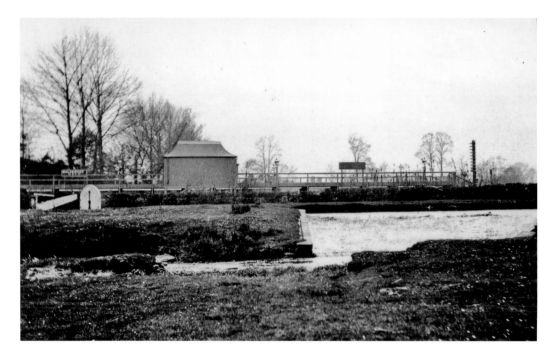

Wolvercot Halt & Siding

Wolvercot Junction, 2 miles 72 chains to the north of Oxford, is the point at which the OW&WR line diverges from the Birmingham route. There was no station at the point of bifurcation, although on 1 February 1908 a halt known as 'Wolvercot Platform' was opened half a mile to the south of the junction. The upper view shows the halt around 1912, while the lower photograph shows the signal box at nearby Wolvercot Siding. Wolvercot Platform was closed as a wartime economy measure in January 1916.

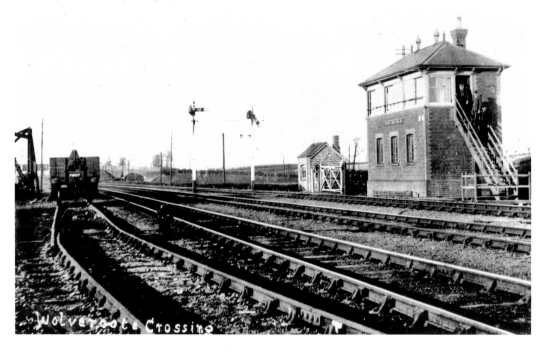

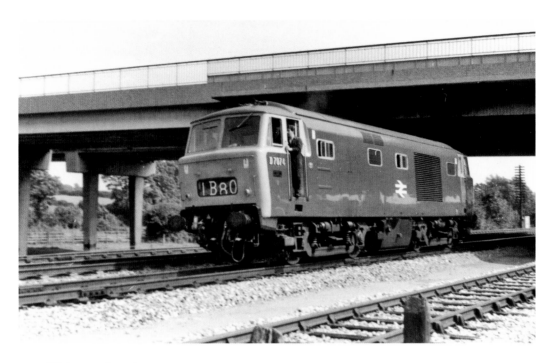

Wolvercot Junction

Above: 'Hymek' class '35' diesel-hydraulic locomotive No. D7074 shudders to a stop beneath the Oxford Bypass Bridge at Wolvercot in 1968. Despite its spotless external condition, the engine had suffered a serious mechanical failure, and was waiting to be hauled back to Oxford by another locomotive. *Below*: Wolvercot Junction was controlled from a standard GWR signal box sited on the down side of the running lines near the A40 road bridge. This hip-roofed cabin, which had a 35-lever frame, was closed in 1973.

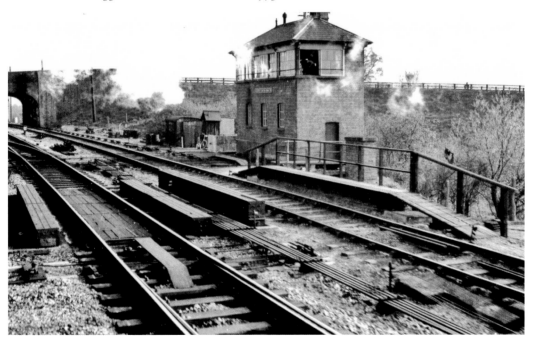

13

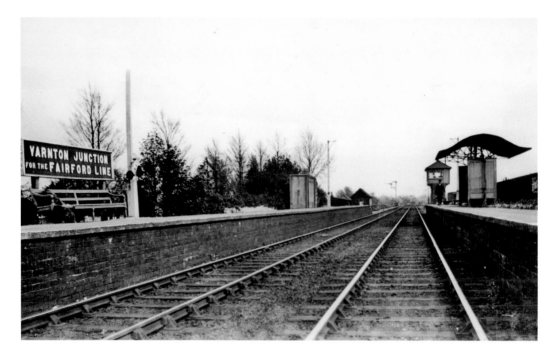

Yarnton Junction

Diverging north-westwards on to the OW&WR route, trains soon reach the site of Yarnton Junction, 3 miles 65 chains from Oxford, which was opened in conjunction with the Witney Railway in 1861. This station was laid out with three platforms, although the outer 'branch' platform line was used as a siding; the Yarnton Loop diverged eastwards at the south end of the platforms. The upper picture shows the platforms around 1930, while the lower photograph shows a High Speed Train (HST) passing Yarnton in 2009.

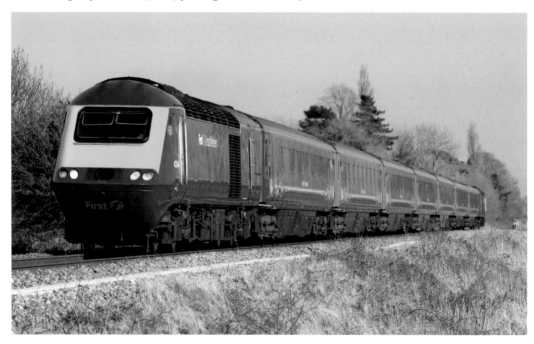

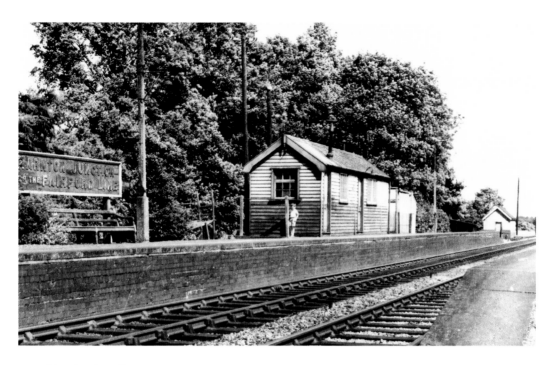

Yarnton Junction

Yarnton was a curiously isolated station without road access, and looking at its primitive facilities, it is easy to sympathise with the Witney Railway directors who, in the 1860s, had complained that the station was 'unfinished'. Yarnton was closed in 1962 but the junction remained in use until the demise of the Witney Railway in 1970. The picture above depicts the wooden station building that was erected around 1935 to replace an earlier structure; the colour picture, in contrast, shows the station site in 2013.

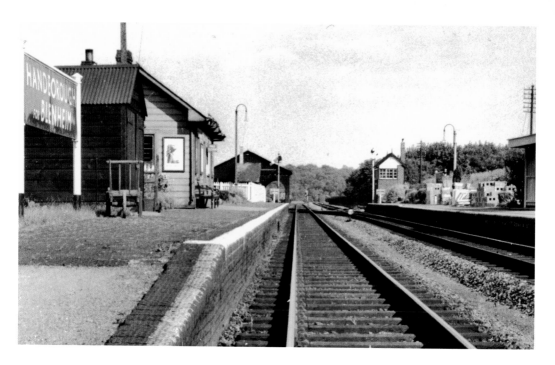

Handborough for Blenheim

With the trackbed of the Witney Railway momentarily visible to the left, trains head north-west along the Evenlode valley, which provides a convenient route into the Cotswolds. Handborough (7 miles 1 chain), now the first stopping place, has just one platform – the OW&WR main line having been reduced to single track between Wolvercot Junction and Ascott-under-Wychwood in 1971. The upper view shows the station with its Victorian infrastructure still intact around 1963, while the recent photograph shows the station after rationalisation. *Inset*: A GWR privilege return ticket from Oxford to Handborough, issued on 4 January 1966.

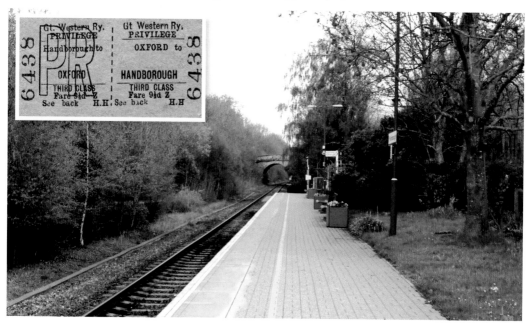

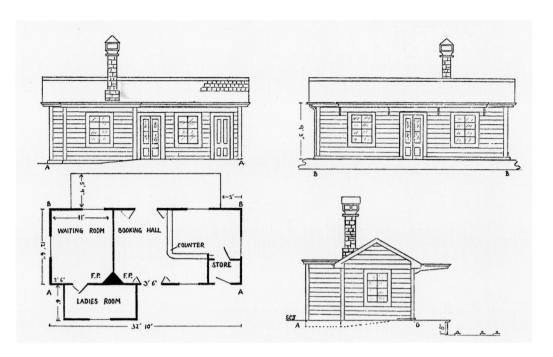

Handborough for Blenheim: The Station Building

Handborough (now known as 'Hanborough') was opened in 1853 as one of the original stations on the 'Cotswold line', and its station building was a typical OW&WR design. The accompanying plan, based on a contemporary drawing, shows the original 'open-plan' booking office, which was later subdivided to form a separate ticket office and waiting room. The lower view provides a glimpse of the signal box and the standard OW&WR timber goods shed.

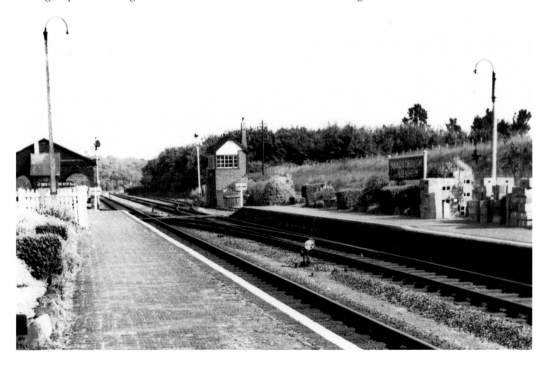

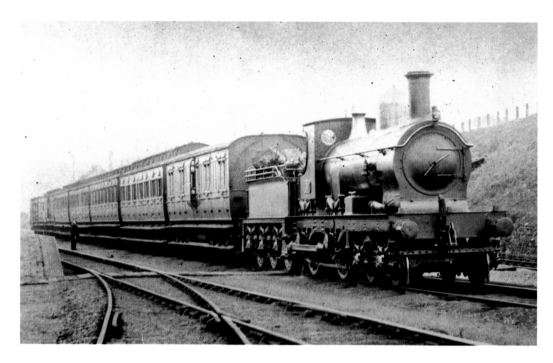

Handborough for Blenheim

Above: '3521' class 4-4-0 No. 3557 at Handborough, *c.* 1905; this locomotive started life as a 7-foot gauge 0-4-2T, but it was reconstructed as a standard-gauge 4-4-0 after the abolition of the broad gauge. *Below*: This contrasting modern view was taken in May 2012, and shows class '165' unit No. 165202 alongside the former up platform. The abandoned down platform is hidden by bushes and trees in the background.

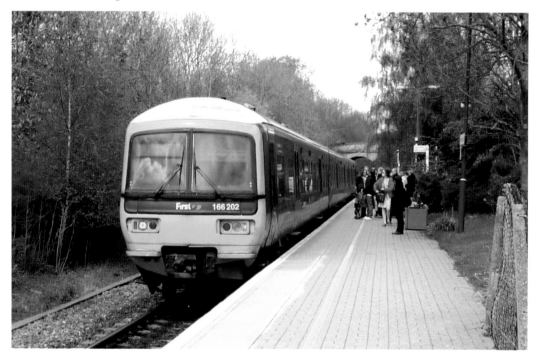

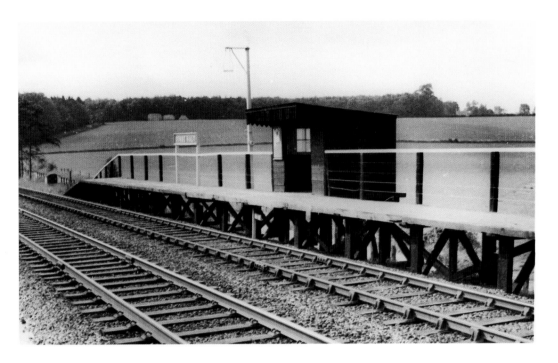

Combe Halt

Combe Halt, 8 miles 31 chains from Oxford, was opened on 8 July 1935. It originally featured staggered up and down platforms, which were perched precariously on the sides of the embankment. There were no public goods facilities, although a private siding formerly served the neighbouring Combe sawmill on the down side of the line. The above picture shows the up platform around 1963, while the view below shows the down platform on a summer evening in 1968. *Inset*: A British Railways second-class single ticket from Oxford to Combe Halt issued on 23 February 1970; note the spelling mistake!

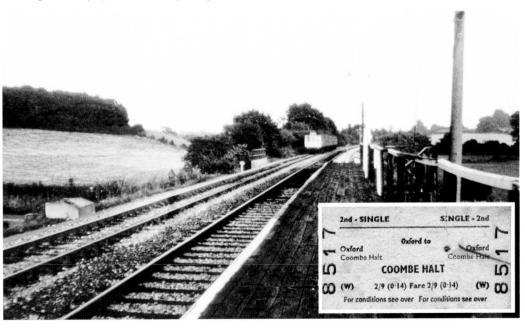

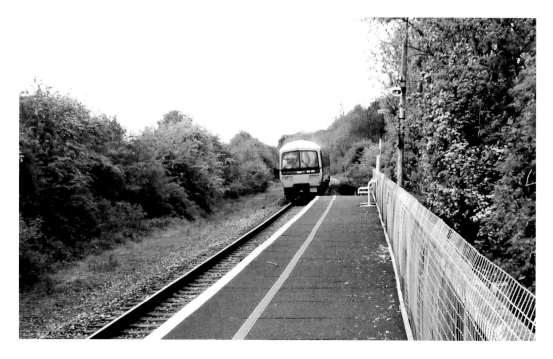

Combe Halt: Grintley Hill Bridge

There is currently just one platform on this now-singled section of the Oxford, Worcester & Wolverhampton main line, as shown in the upper photograph, which was taken in May 2012 and is looking towards Worcester. *Below*: Continuing north-westwards, the railway plunges beneath a soaring occupation bridge known as Grintley Hill Bridge, which spans a deep cutting to the north of Combe Halt and is said to be the highest of its kind on the former GWR system.

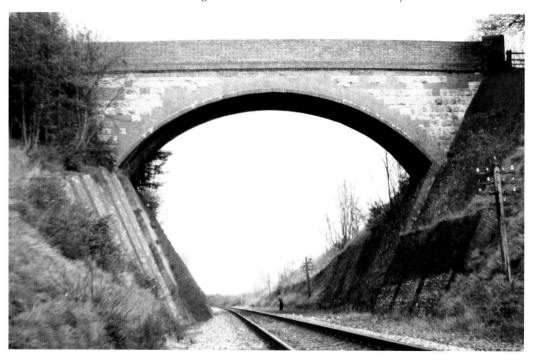

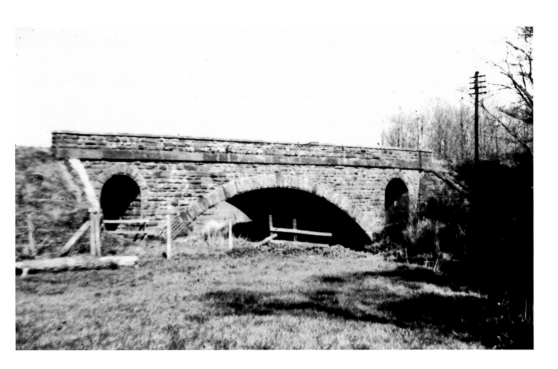

Bridges Near Combe Halt

Crossing and re-crossing the tranquil waters of the River Evenlode, trains climb steadily into the Cotswolds. The river bridges on this section are of distinctive design, with three arched spans; the upper view shows one of these typical OW&WR under-bridges near Fawler, while the lower picture depicts a class '35' diesel-hydraulic heading northwards near North Leigh Roman Villa in September 1971. The locomotive is in its original green livery, with off-white window surrounds and an apple green stripe along the lower body side.

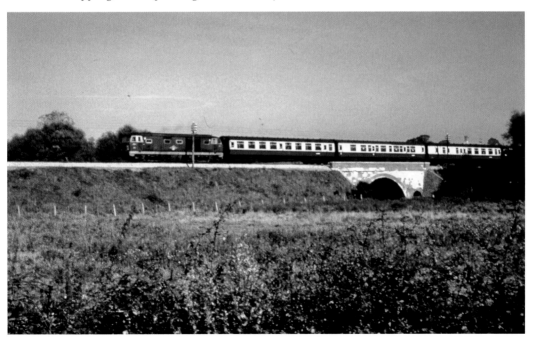

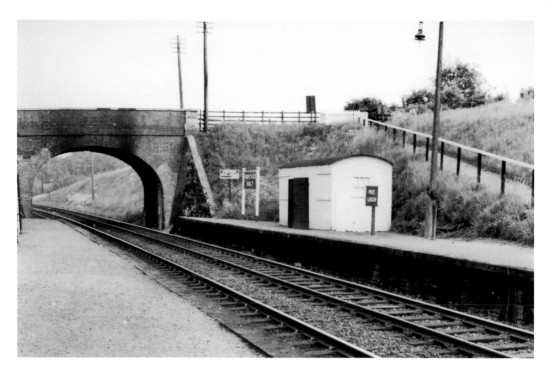

Finstock Halt

Finstock Halt (11 miles 50 chains), the next stopping place, was another relatively late addition to the railway network, having been opened by the GWR on 9 April 1934. It was originally equipped with earth-and-sleeper platforms and arc-roofed waiting shelters, as shown above. The former up platform was taken out of use when the line was reduced to single track in 1971 and, in its present form, Finstock has just one platform and a waiting shelter, as shown in the lower photograph.

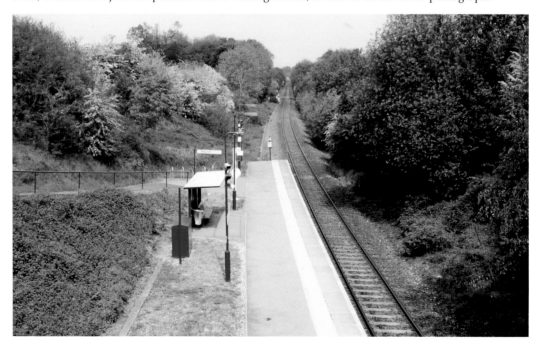

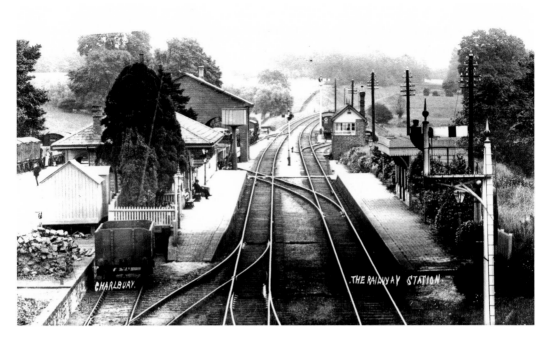

Charlbury

Cuttings hide the railway from Cornbury Park before trains reach Charlbury (13 miles 20 chains). There were formerly four sidings and a crossover here, but this infrastructure has now been removed, along with the station's wooden Brunelian goods shed. The historic station building, however, survives as one of the few remaining examples of Brunel's minor station designs. The upper picture shows the station around 1912, while the colour view was taken a century later, in 2012; the new down platform can be seen to the right.

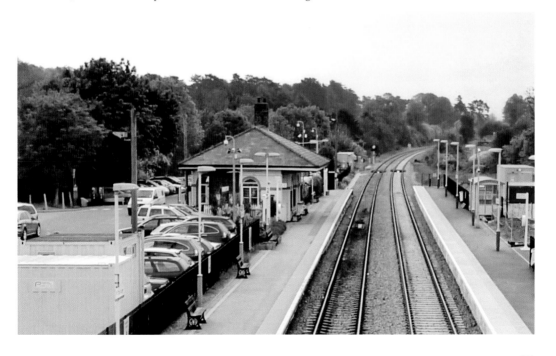

23

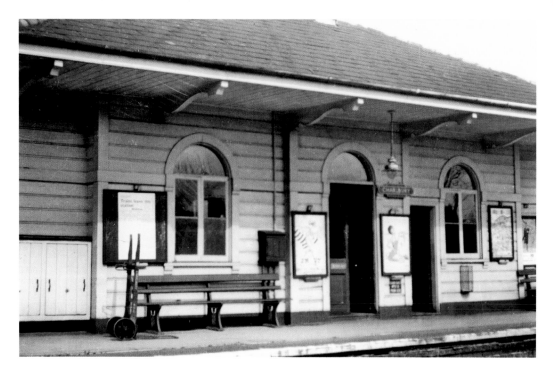

Charlbury: The Brunelian Station Building

The wooden chalet-style structure, which stands on the up platform, was declared a listed building in 1975. The upper view shows the platform façade in 1965; the double doors gave access to a booking hall, the ticket office being to the left, while the ladies' waiting room, which at that time had its own doorway, was situated to the right. The lower picture shows the rear elevation around 1970. The projecting bay is not shown on the OW&WR plans, and may be a later addition.

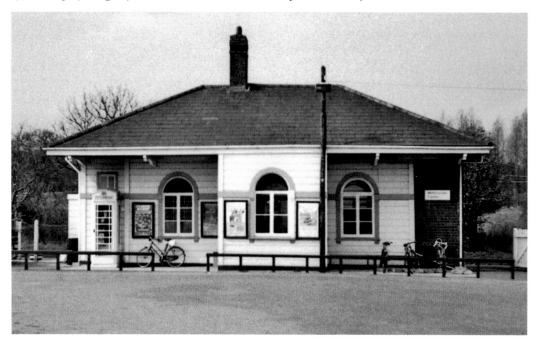

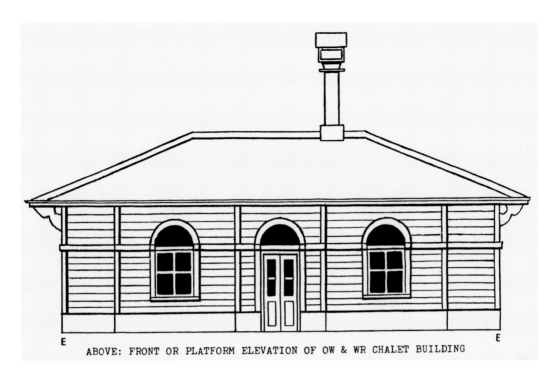

ABOVE: FRONT OR PLATFORM ELEVATION OF OW & WR CHALET BUILDING

Charlbury: The Brunelian Station Building

Above: The front elevation of a typical Brunelian 'chalet' building based upon the original OW&WR drawings. These distinctive buildings were intended for use at the 'express' stations at which all trains would stop and, presumably for that reason, they were equipped with public toilet facilities. *Below*: A recent view of Charlbury's historic station building, taken in February 2013; the ladies' room doorway that can be seen on page 24 has now been filled-in, the former ladies' room having become a general waiting room.

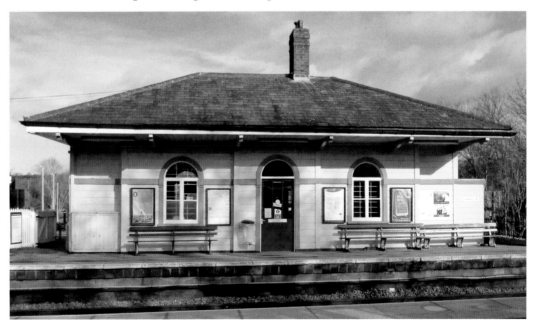

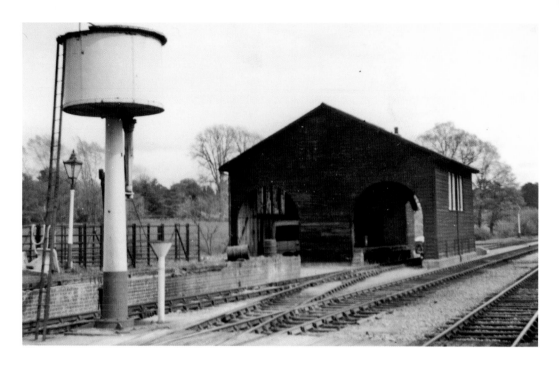

Charlbury: Goods Facilities

Above: The infrastructure at Charlbury included a timber-framed goods shed with a central trans-shipment platform and separate entrances for rail and road vehicles. These Brunel-designed buildings, which measured approximately 67 feet by 45 feet at ground level, were provided at most stations on the OW&WR route. *Below*: In addition to the main goods yard, there was a separate loading dock at the north end of the up platform, this facility being served by a dead-end siding with a 'kick-back' spur. *Inset*: A British Railways second-class special day return ticket from Charlbury to Worcester, issued on 5 August 1987.

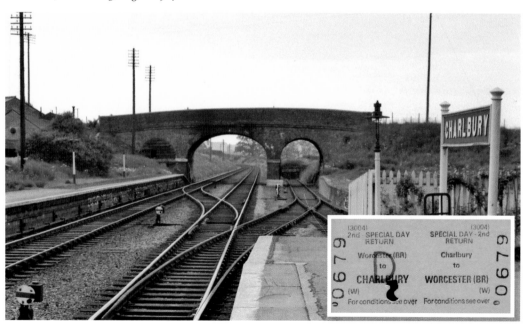

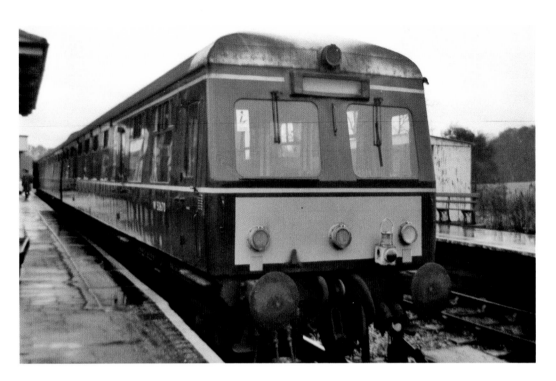

Charlbury: Local Trains

The upper view depicts a Swindon 'Cross Country' unit waiting in the up platform at Charlbury with a southbound local service during the mid-1960s. The down platform, which can be seen to the right of the train, was taken out of use when the line was singled in 1971. The lower photograph, taken twenty years later, shows a handful of travellers waiting patiently for their train on the former up platform – the redundant down platform had, by that time, been totally obliterated.

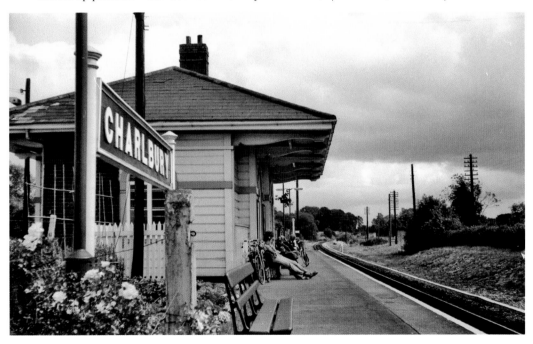

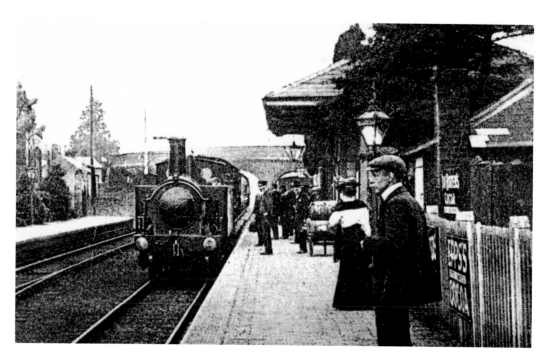

Charlbury: Local Trains Then and Now

Above: An Edwardian postcard showing an up local train at Charlbury; the engine appears to be a 'Metro' class 2-4-oT. The hip-roofed building that can be seen to the right of the mustachioed gentleman with the cloth cap was the weigh house. *Below*: A similar scene, photographed over sixty years later, shows Pressed Steel class '117' set No. L403 in the platform at Charlbury; this three-car DMU was formed of vehicles 51336, 59488 and 51378.

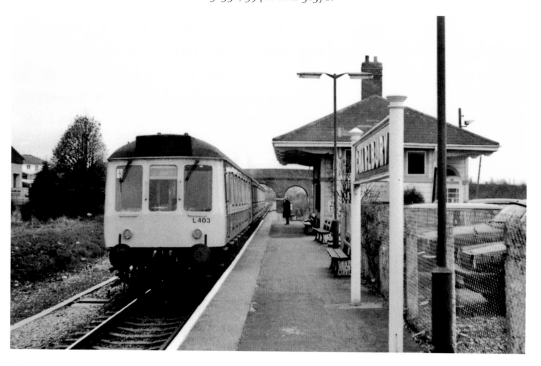

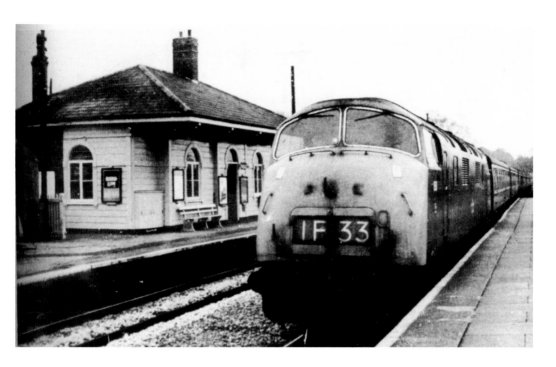

Charlbury: 'Warship's and 'Hymek's

Main line services between Hereford, Worcester and Paddington were hauled by 'Castle' class 4-6-0 locomotives until 1965, after which the Worcester expresses were typically worked by 'Hymek' class '35' and 'Warship' class '43' diesel-hydraulics. The upper view shows class '43' locomotive No. D858 *Valorous* with a down train at Charlbury in 1968, while the lower photograph depicts class '35' No. D7057 with an up working in that same year. *Inset*: A British Railways first-class privilege ticket issued to the author at Charlbury on 25 June 1981.

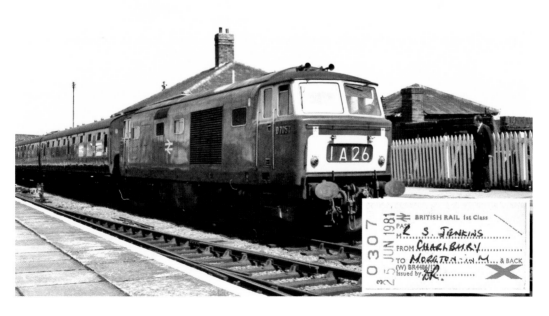

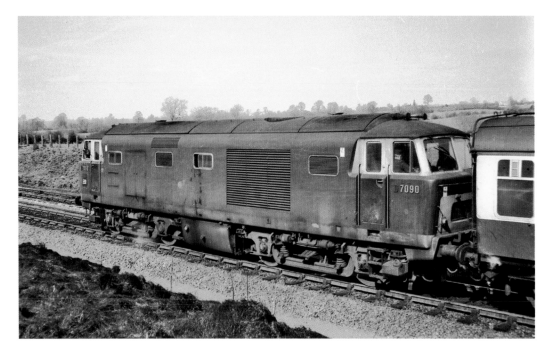

Charlbury

Above: Class '35' locomotive No. 7090 leaves Charlbury with a down working in 1968. These diesel-hydraulic locomotives had very short lives, and they had all been withdrawn by the 1970s. *Below*: Double track working was reinstated over 4 miles of line between Ascott and Charlbury on 6 June 2011. This recent photograph shows a class '180' unit passing over the junction between single and double track, which is sited just to the south of Charlbury, near the Cornbury Park overbridge.

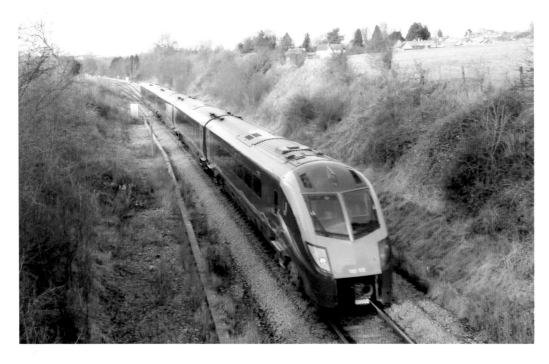

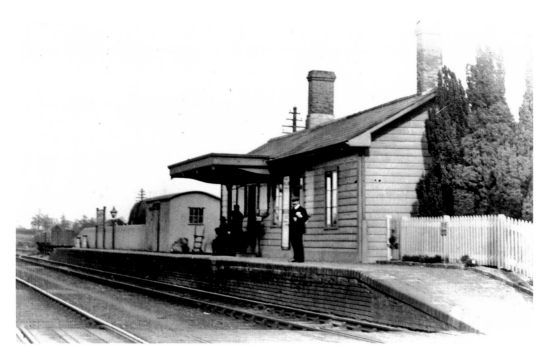

Ascott-under-Wychwood

Ascott-under-Wychwood (16 miles 73 chains) was opened on 4 June 1853. Its track layout incorporated up and down platforms, with a wooden station building on the down side, and a level crossing immediately to the west. The goods yard, sited to the east of the down platform, was able to handle coal traffic and general merchandise. The upper picture is looking towards Paddington, while the lower view is looking in the opposite direction towards Worcester.

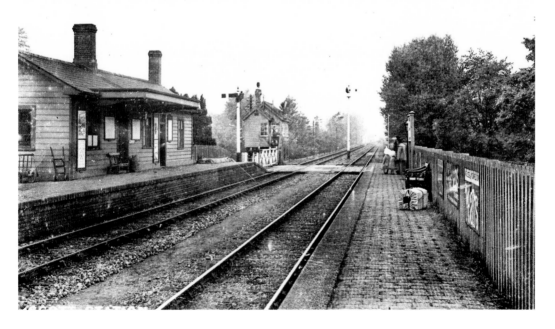

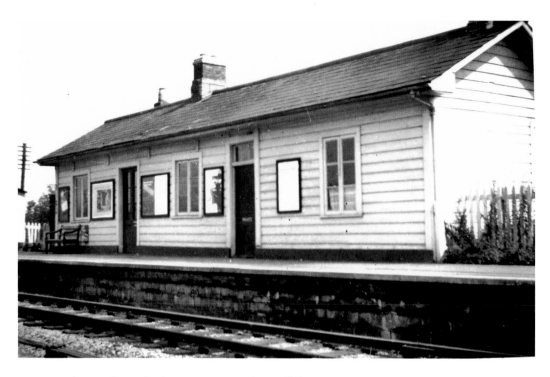

Ascott-under-Wychwood: The OW&WR Station Building

These detailed front and rear views show the typical OW&WR-style station building that formerly graced the down platform at Ascott-under-Wychwood. This example was slightly larger than usual, suggesting that the building had been extended at some stage in its career – possibly to provide residential accommodation for the stationmaster and his family. In this context it is interesting to recall that 'Mr Whenman' was appointed Ascott's first 'station clerk' in 1853 at a salary of £52 per annum.

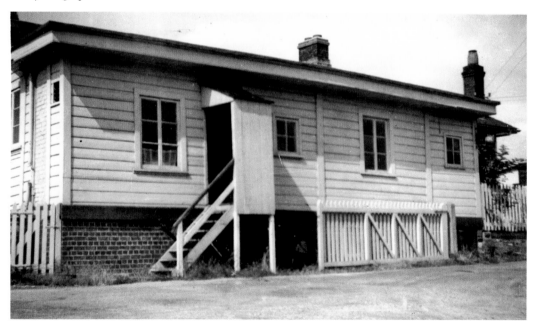

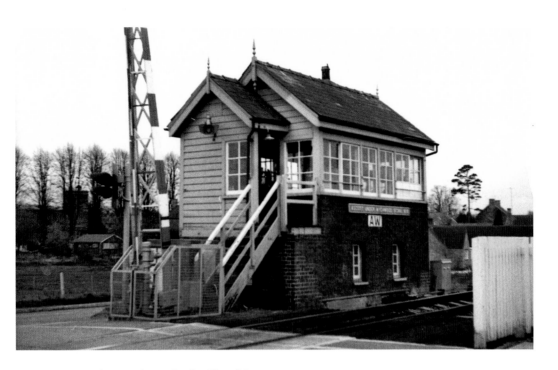

Ascott-under-Wychwood: The Signal Box

Ascott-under-Wychwood achieved operational significance when the line was partially-singled in 1971, as it marked the commencement of a section of double track that continued northwards as far as Moreton-in-Marsh. This situation continued until the reinstatement of double track working in June 2011, although the traditional signal box was retained to control the line between Kingham and the outskirts of Oxford, its levers having been replaced by a new push-button panel. *Above*: The box in the 1980s. *Below*: A recent view, taken in January 2013.

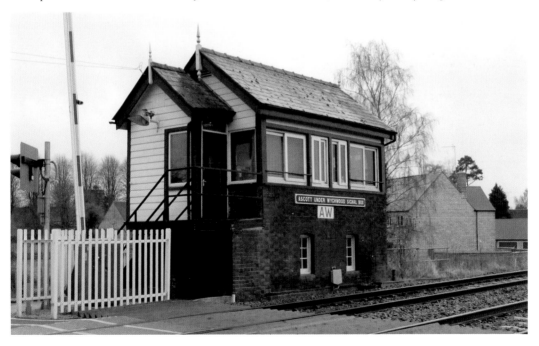

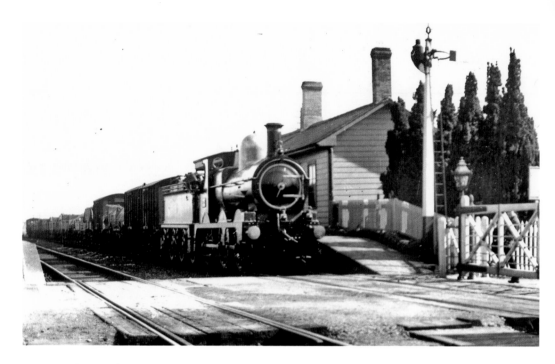

Ascott-under-Wychwood

The sepia view, from an Edwardian postcard, depicts an Armstrong 'Standard Goods' 0-6-0 standing alongside the down platform with a lengthy freight train, while the colour photograph, which was taken from a similar vantage point, shows the down platform on a stormy day in May 2012. The up platform, visible in the foreground, had recently been reinstated in connection with the re-doubling of the line between Ascott and Charlbury.

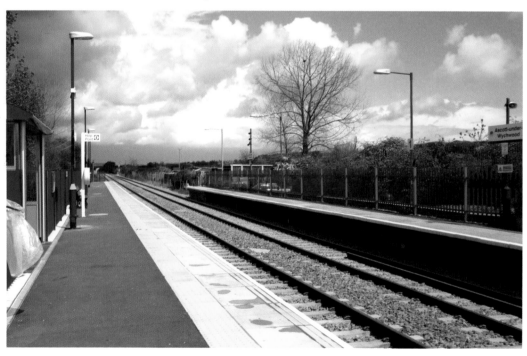

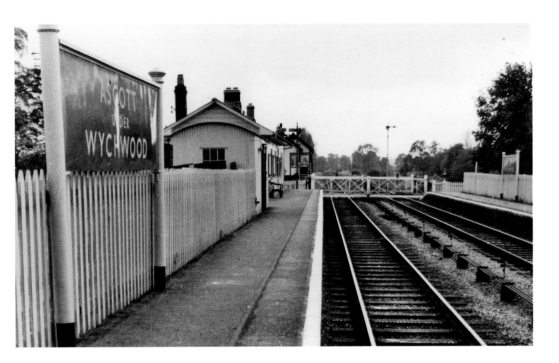

Ascott-under-Wychwood

Two final views of Ascott-under-Wychwood station during the early 1960s. The upper photograph is looking towards Worcester along the down platform, and the lower view shows the up platform, with its simple waiting shelter and single platform seat. This wayside station was never particularly busy; in 1903 it issued 5,232 tickets and handled 2,433 tons of freight, the corresponding figures for 1934 being 7,716 tickets and 2,296 tons respectively. It is estimated that Ascott generated 2,264 passenger journeys in 2009/10, and 1,658 in 2010/11. *Inset*: A British Railways second-class single ticket from Oxford to Ascott-under-Wychwood, issued on 7 April 1966.

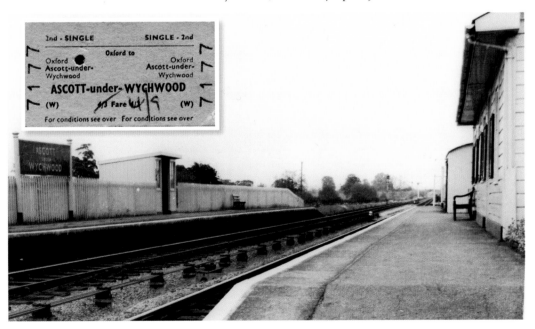

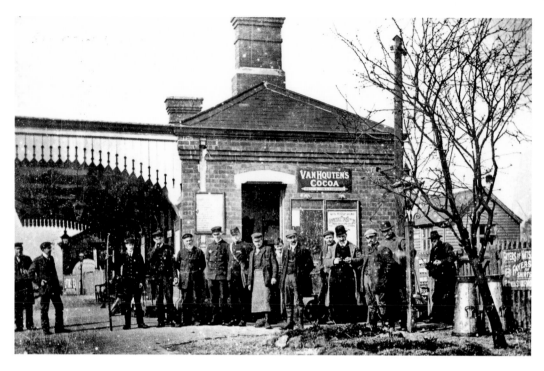

Shipton-for-Burford: The Station Building

When opened in 1853, Shipton-for-Burford station (18 miles 19 chains) had been very similar to Ascott-under-Wychwood, but its original wooden station buildings were replaced in the late Victorian period, when the GWR constructed a standard hip-roofed station building, with tall chimneys and a projecting canopy. The upper view shows a group of GWR staff and local traders beside the station building, *c.* 1908, while the lower photograph, which was taken from a similar angle in August 2012, shows the up and down platforms.

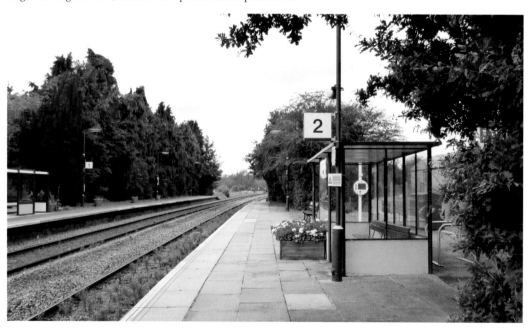

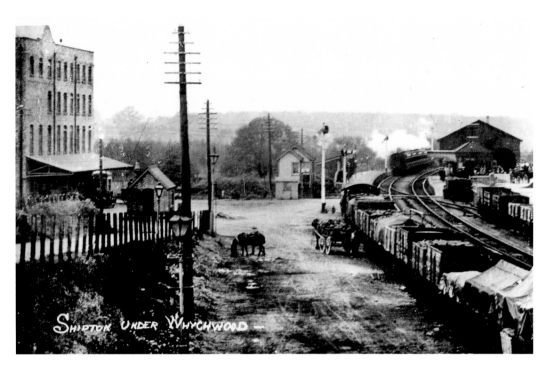

Shipton-for-Burford

There was a fully-equipped goods yard on the up side, while a private siding on the down side served the adjacent flour mill. The upper picture shows the mill siding around 1912, with the station and goods shed visible in the distance. The colour photograph provides a view of the down platform in 1971, the small, brick-built waiting shelter being partly-hidden by foliage. This small structure has now been replaced by a 'bus stop' style shelter, as shown on the previous page. *Inset*: A British Railways second-class single ticket from Oxford to Shipton, issued on 17 June 1967.

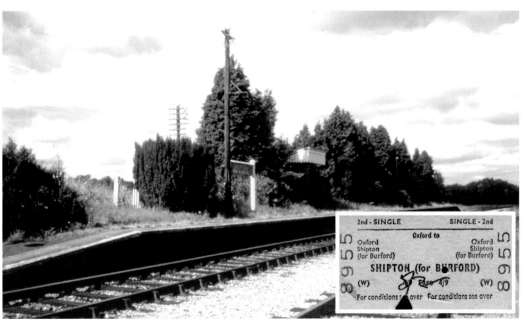

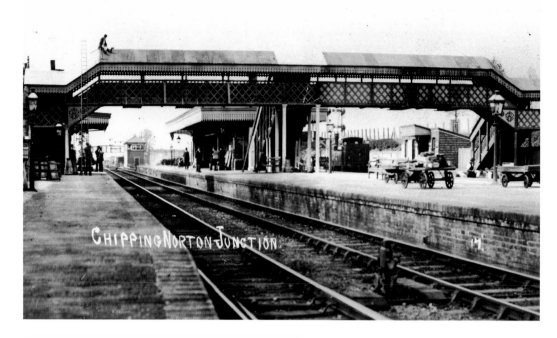

Kingham: A Country Junction

The railway continues north-westwards to Kingham, 21 miles 19 chains from Oxford, which was opened in August 1855 in connection with the Chipping Norton branch – its original name being 'Chipping Norton Junction'. Seven years later, the opening of the Bourton-on-the-Water branch led to an increase of facilities, while important developments took place in the 1880s, when the GWR rebuilt the station with four platforms and extensive new station buildings. The Chipping Norton and Bourton-on-the-Water branch lines had, in the meantime, been extended to Banbury and Cheltenham respectively, and Kingham thereby became an important interchange between the OW&WR and the Banbury & Cheltenham Direct route. The upper picture provides a general view of the station, *c.* 1912, while the view to the left is looking north in 2012. The girder bridge that can be seen in the distance carried the Banbury & Cheltenham route across the OW&WR main line.

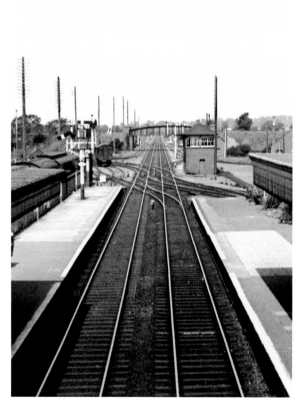

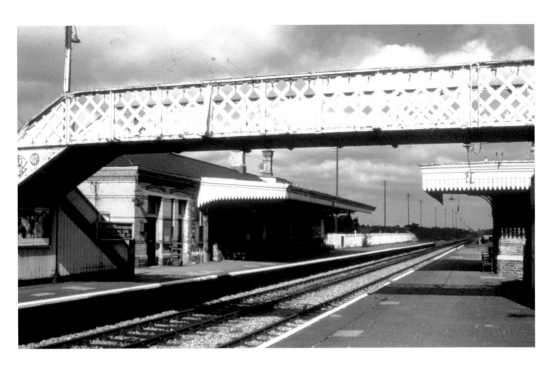

Kingham: Victorian Architecture

Above: Kingham's station buildings were single-storey, hip-roofed buildings with projecting canopies. The main building on the down side was completed in 1883. The four platforms were linked by a standard GWR lattice-girder footbridge, which extended eastwards to reach the adjacent Langston Arms Hotel. The footbridge was fully roofed, and in the 1930s a small, privately-run refreshment kiosk was provided in the restricted space beneath the steps on the island platform. *Below*: The Langston Arms Hotel can be seen to the left. *Inset*: A British Railways second-class cheap day return ticket from Kingham to Charlbury, issued on 8 February 1974.

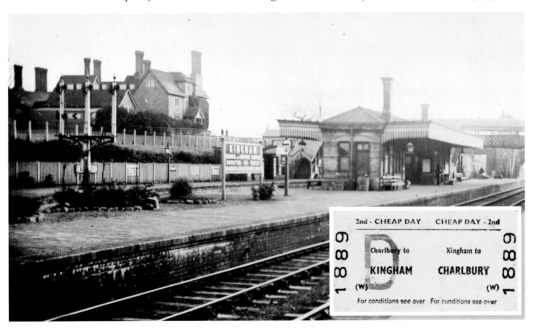

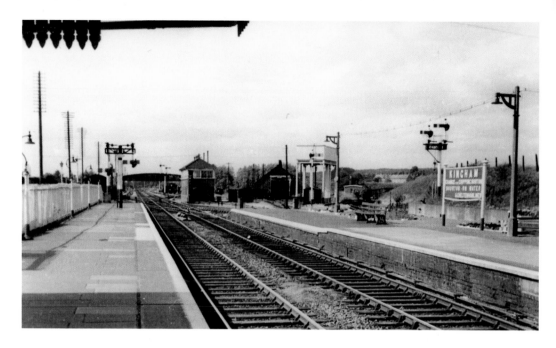

Kingham: The New Station Building

Above: Looking northwards along the down platform. The engine shed that can be seen in the distance was erected around 1900 in place of an earlier structure. Kingham's main goods-handling facilities were situated to the left of the fence on the down side. Three dead-end sidings were available for a range of traffic including coal, livestock and general merchandise. *Below*: The 1883 station buildings have now been replaced by a much smaller structure, although the GWR footbridge still links the surviving platforms.

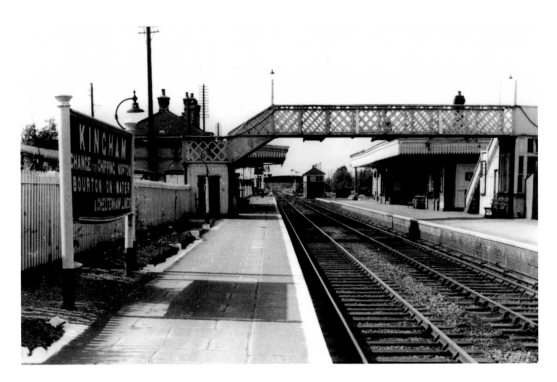

Kingham: Then and Now

These contrasting views underline the many changes that have taken place at Kingham in recent years. The upper view, dating from around 1963, shows the station with its Victorian infrastructure still in place, whereas the colour view, taken in August 2012, reveals that, apart from the main line platforms and the footbridge, very little of the old station has survived. There has also been little attempt to cut back the rampant vegetation that now surrounds the station on all sides.

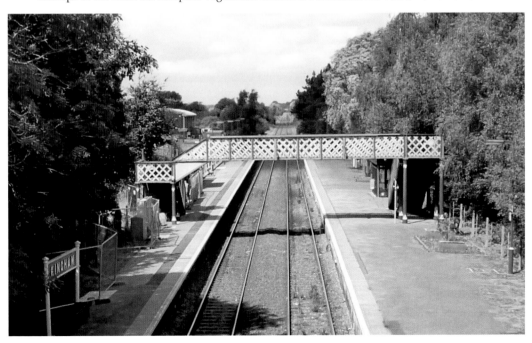

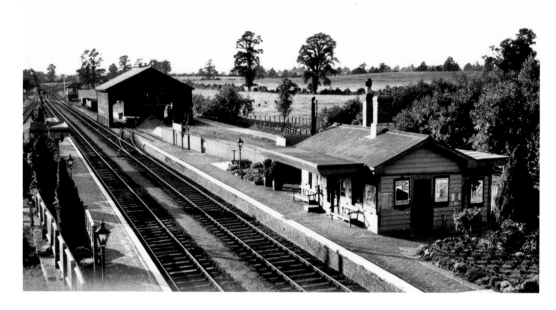

Adlestrop: 'Yes I Remember Adlestrop...'

Leaving Kingham, down services hurry northwards along a straight section of double track. The railway enters Gloucestershire about 2 miles further on and, shortly afterwards, trains rush past the site of Adlestrop station. This wayside station, immortalised by Edward Thomas (1878–1917) in his poem 'Adlestrop', was a typical OW&WR stopping place, with a wooden station building and goods shed on the up side, and an additional siding on the down side. These two postcards show the famous station during the Edwardian period.

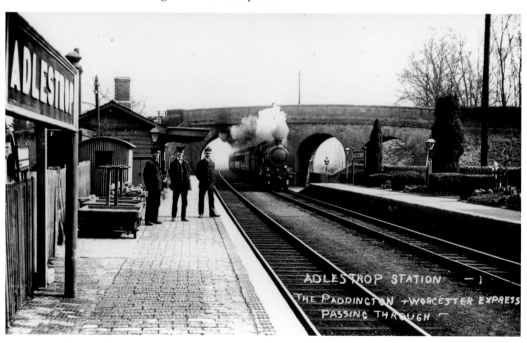

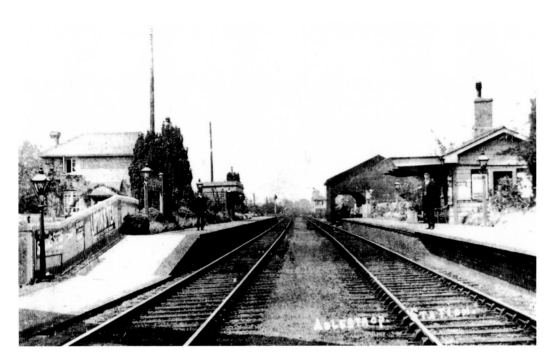

Adlestrop: 'No one left and no one came...'

The writer and critic Anthony Gill has argued that Edward Thomas was one of our greatest war poets. Written in 1915, 'Adlestrop' recalls a journey made by the poet on 24 June 1914; the war is not mentioned, but the poem is nevertheless an 'almost unbearable memorial to the trenches, not as despatches from the front ... but as a departing view of what was fought for, and what was lost'. *Above*: Another glimpse of the station as Thomas would have seen it. *Below*: Adlestrop around 1963.

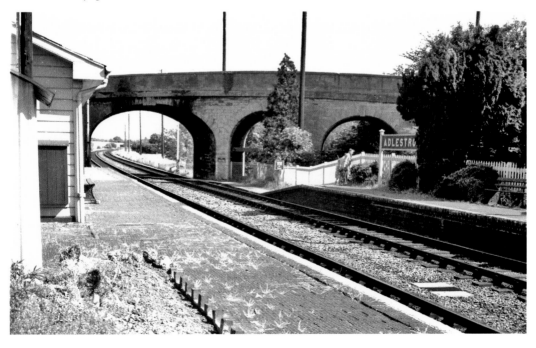

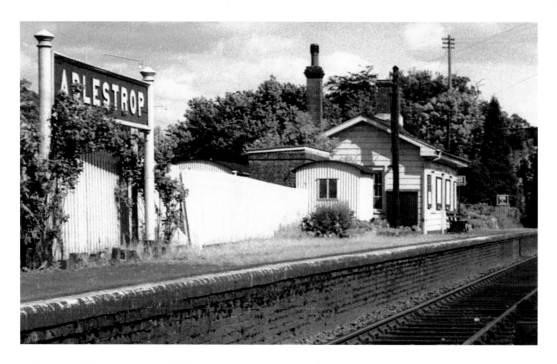

Adlestrop: 'What I saw was Adlestrop – only the name...'

Sadly, Adlestrop station was closed on Saturday 1 January 1966. The old wooden buildings were subsequently demolished, but a GWR platform seat and one of the station nameboards have been placed in the village bus shelter, together with a copy of Edward Thomas's elegiac poem, which has immortalised this quiet Cotswold village. The poet, who had recently been commissioned as a Second Lieutenant in the Royal Garrison Artillery, was killed at the Battle of Arras on 9 April 1917.

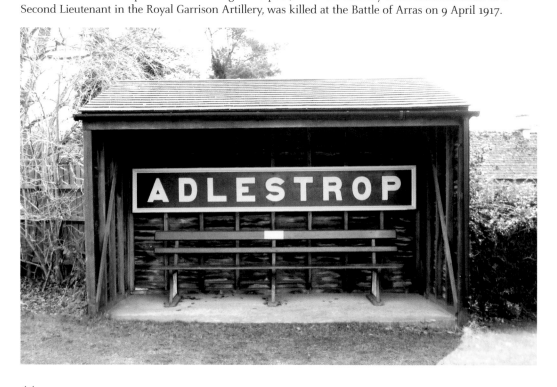

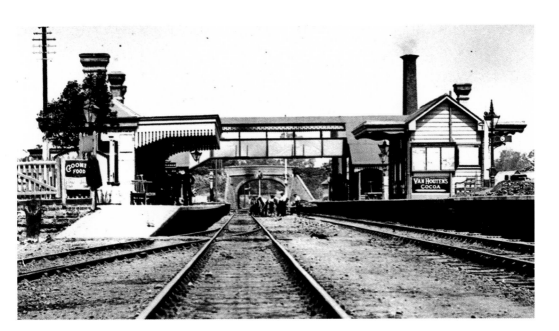

Moreton-in-Marsh: The Stratford & Moreton Railway

Still climbing, the railway approaches Moreton-in-the-Marsh. The Evenlode, now little more than a winding stream, can be seen to the left of the railway, as the village of Evenlode flashes past on the right-hand side.

Moreton, 28 miles 21 chains from Oxford, was first served by rail on Tuesday 5 September 1826, when the Stratford & Moreton Railway was ceremonially opened as a rail link between Moreton and the Stratford Canal. This pioneering horse-worked line was taken over by the Oxford, Worcester & Wolverhampton Railway in the 1850s and, for the next few years, the tramway was worked as a branch of the OW&WR.

The southern section of the route was subsequently adapted for steam operation, and on 1 July 1889 the line was reopened between Moreton-in-Marsh and Shipston-on-Stour as a conventional branch line. The upper view shows Moreton-in-Marsh station, looking north towards Worcester around 1900, while the lower photograph was taken about sixty years later.

Moreton-in-Marsh: The Down-Side Station Building

The down platform was originally equipped with wooden buildings, which are presumed to have been of the usual OW&WR type, but in 1872 the GWR started to rebuild the station in its latest architectural style, and when the new brick building was completed in the following year the old wooden building was demolished. These two photographs show the 'new' station building from the rear, the upper view having been taken around 1900, while the colour photograph dates from 1971.

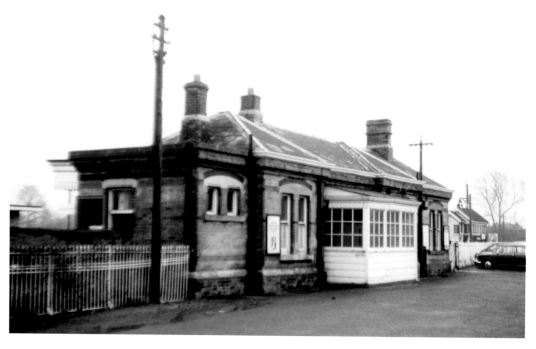

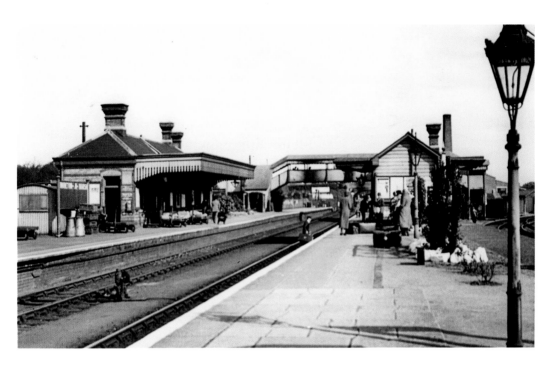

Moreton-in-Marsh: The Down-Side Station Building

The upper view shows the station during the 1930s, while the lower photograph was taken by Mike Marr over seventy years later. The 1930s photograph was clearly taken after the cessation of Shipston branch passenger services, as the words 'Change here for the Shipston-on-Stour Tramway' have been expunged from the station nameboards. Both views are looking north towards Worcester.

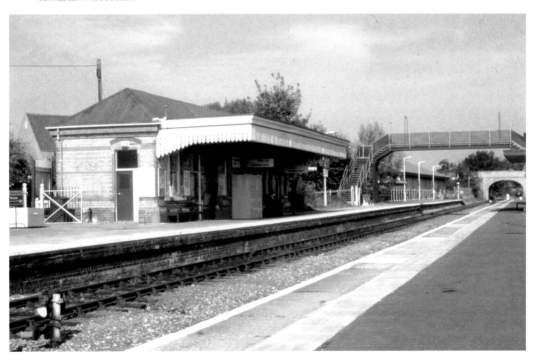

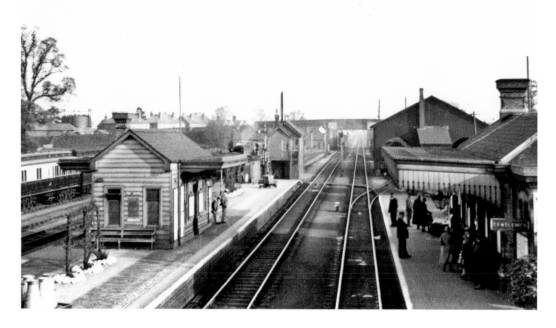

Moreton-in-Marsh: The Island Platform

Above: A general view of the station, looking south towards Paddington during the 1930s. The up platform was an island, with tracks on either side – the outer face being used by Shipston branch trains. *Below*: A similar view, taken from the same angle in 1971. Although the Shipston-on-Stour branch had been closed to passengers as long ago as 1929, the third platform remained in use in connection with local services from Oxford, which terminated at Moreton.

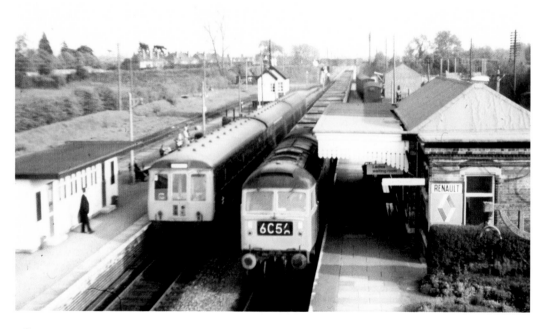

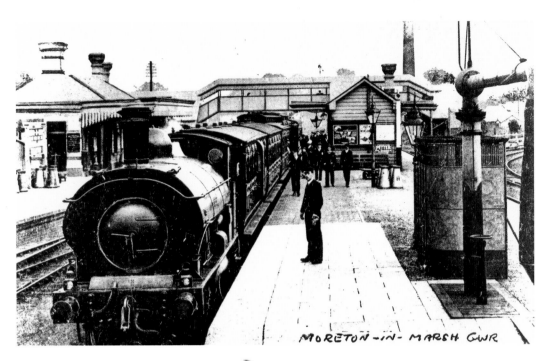

MORETON-IN-MARSH GWR

Moreton-in-Marsh: Steam and Diesel Motive Power

Two contrasting views of motive power at Moreton-in-Marsh, the upper view showing an 0-6-0 saddle tank in the up platform with a local passenger working, while the colour photograph, copied from a 35-mm colour slide, shows class '47' diesel-electric locomotives passing with up and down passenger services. The line had, by that time, been singled, and the down train was waiting to proceed northwards as soon as the southbound working had cleared the single-line section to Norton Junction.

Class '47' locomotives first appeared on the OW&WR route in 1965, but they became predominant after the untimely demise of the Western Region diesel-hydraulics in the 1970s. Other diesel types, including the class '31' diesel-electrics, also appeared on the line, but they were by no means as successful as the class '47's, which hauled the best trains until the introduction of class '50's in the 1980s.

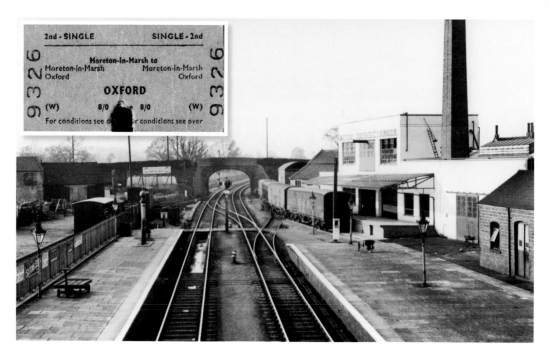

Moreton-in-Marsh: The North End of the Station

Above: The north end of the station viewed from the footbridge around 1930, showing the United Dairies premises which dominated this end of the station site. Part of the old Stratford & Moreton tramway terminus can be glimpsed to the left, while the road overbridge can be seen in the distance. *Below*: A similar view, looking south from the road overbridge, with the dairy to the left; the sharply curved sidings visible on the extreme right ran into the former tramway terminus. *Inset*: A British Railways second-class single ticket from Moreton-in-Marsh to Oxford, issued on 24 August 1966.

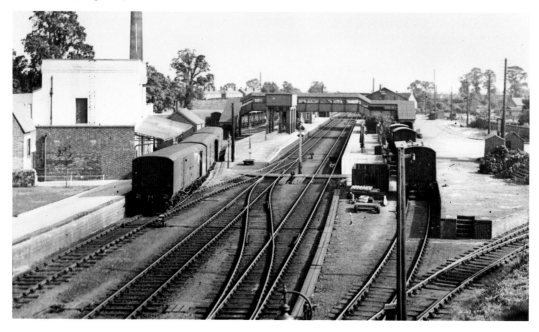

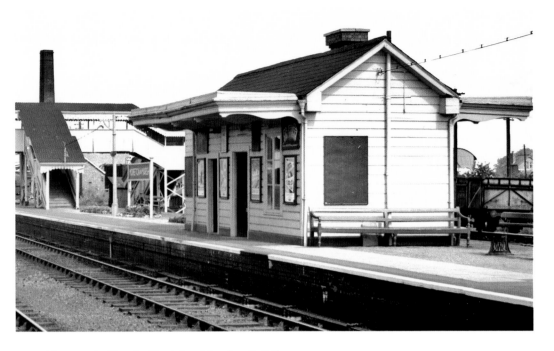

Moreton-in-Marsh: The Island Station Building
The wooden building on the island platform was an OW&WR-style structure, although it may have been enlarged during the Great Western era. The building sported projecting canopies on both sides, as shown in the upper picture. The lower photograph was taken after removal of the platform canopies, which spoiled the appearance of the building. The signal box can be seen on the extreme right of the picture.

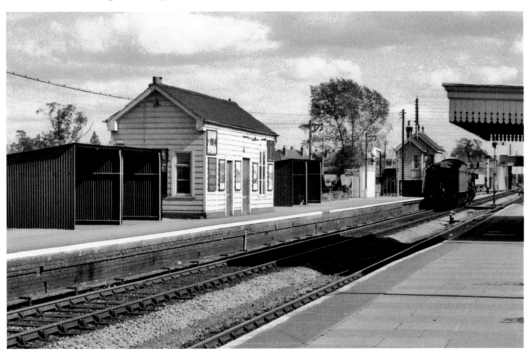

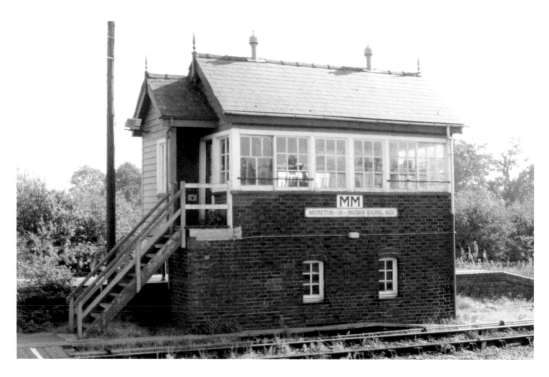

Moreton-in-Marsh: The Signal Box

Above: A detailed look at Evesham Signal Box, which remains in use, and is situated at the south end of the up platform. This brick-and-timber cabin was opened in 1883, and it received a new forty-lever frame in 1911 – although many of the levers are now 'spares'. The building has latterly been fitted with new window frames. *Below:* A view of the rarely-photographed branch platform during the 1960s; Engineering Department wagons occupy the sidings.

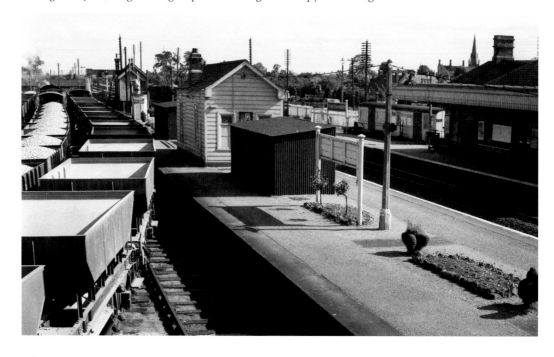

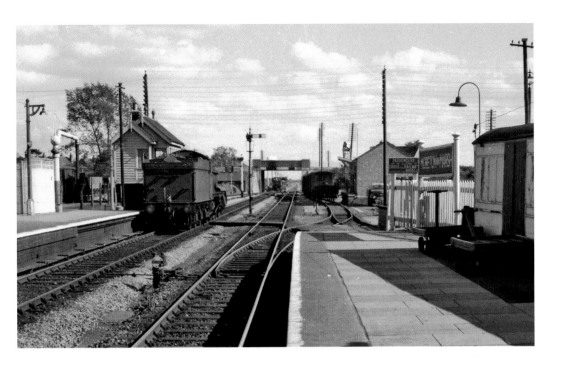

Moreton-in-Marsh

Above: The south end of the station around 1962, with the goods yard visible to the right and an unidentified 4-6-0 locomotive alongside the signal box. *Below:* Class 166 unit No. 166219 leaves Moreton-in-Marsh with the 9:29 a.m. service to Paddington on 6 September 2010. This train had started from Moreton, the empty stock having arrived from Oxford just prior to departure. Although gradually losing its Great Western atmosphere, the signalling and other infrastructure hark back to steam days.

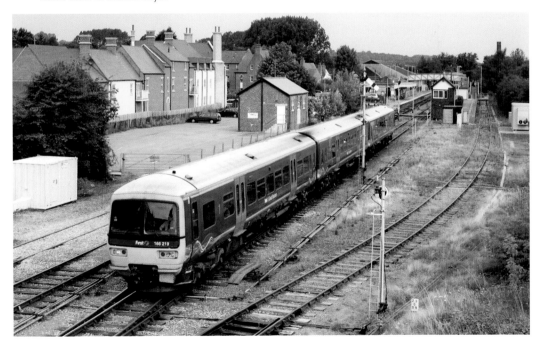

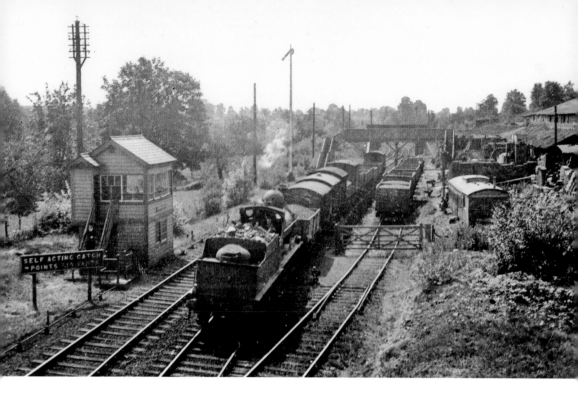

Blockley

On departing from Moreton-in-Marsh, trains run northwards for a further 2 miles to Aston Magna, where a private siding formerly served the Northwick Brick & Tile Works, which is shown in the upper illustration. Beyond, the route continued to Blockley, the next station. The track layout provided here incorporated up and down platforms, a level crossing and a small goods yard; the diminutive wooden station building, shown below, was on the down side.

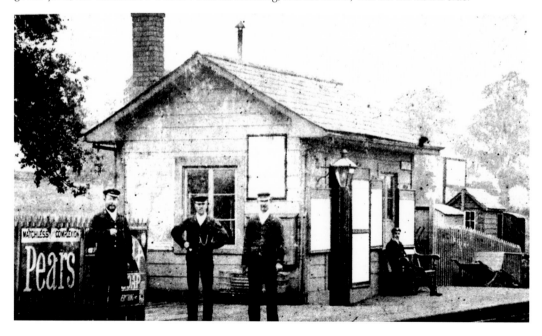

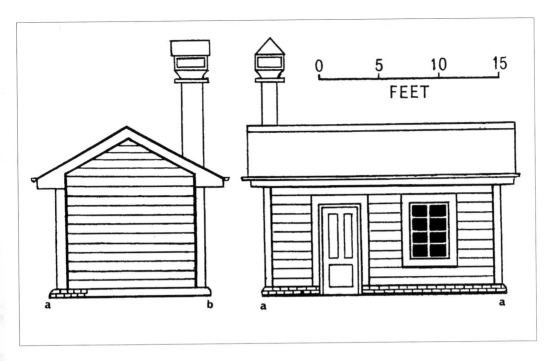

Blockley

The accompanying drawing depicts a timber-framed OW&WR building that was intended for use as a waiting room, although at Blockley a similar structure was utilised as the main station building. Blockley station was rebuilt by the GWR when a new station building was erected, the replacement structure being of timber-framed construction. The roof of the new building can be seen in the lower picture, which is looking towards Worcester. The station was closed in January 1966, and little now remains to mark its site.

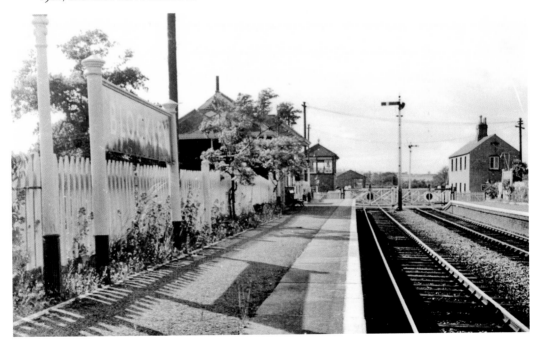

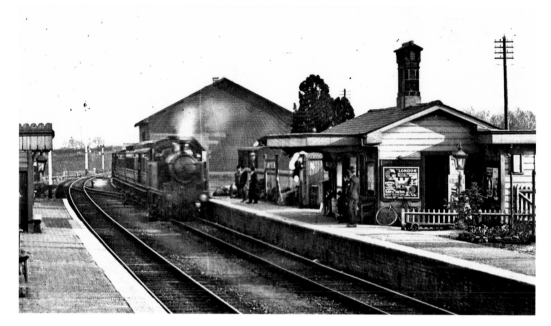

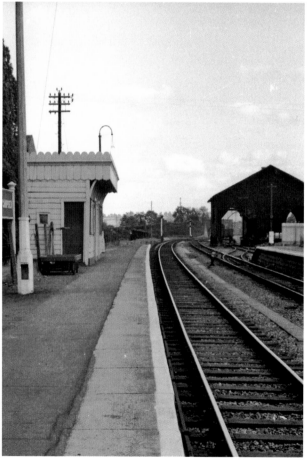

Chipping Campden

Campden (renamed Chipping Campden in 1952), some 2 miles further on, was another typical OW&WR stopping place, with a timber-framed station building of the now familiar OW&WR type on the down platform, and a wooden waiting room on the opposite side. The goods yard, on the down side, contained the usual coal sidings and cattle loading pens, together with a timber goods shed and a gasworks siding.

The upper picture shows a down passenger train entering the station during the Edwardian period; the locomotive is a 'Birdcage' 2-4-2T, and the large wooden goods shed can be seen in the background. The lower photograph, taken around sixty years later, is looking southwards along the up platform, with the goods shed visible in the distance. In 1903, Campden issued 12,833 tickets, while in 1933 the station issued 12,218 ordinary tickets and 27 seasons; freight traffic amounted to around 8,000 tons per annum.

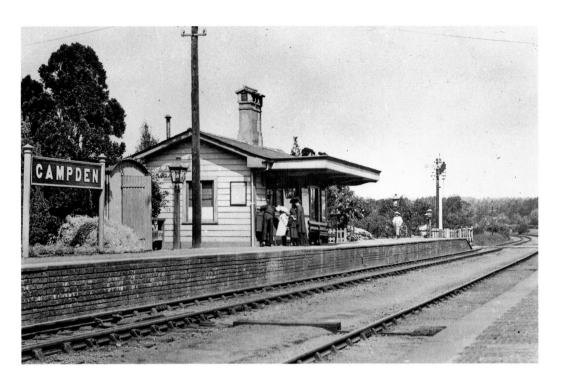

Chipping Campden

Two photographs of Campden station during the Edwardian period: the lower view shows a steam rail-motor car in the up platform. These self-propelled vehicles can be seen, in many ways, as the ancestors of today's DMUs. Campden, which served a popular Cotswold tourist destination, was one of the busiest intermediate stations, but closure nevertheless took place on Saturday 1 January 1966; local campaigners have, for many years, hoped that the station can be reopened.

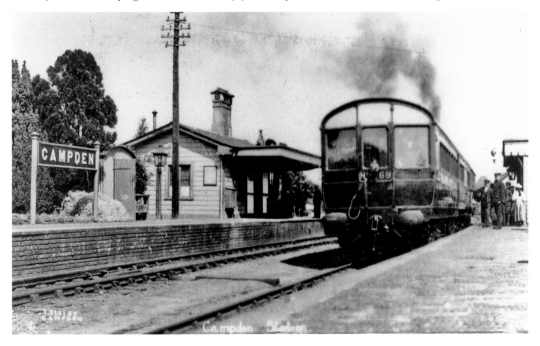

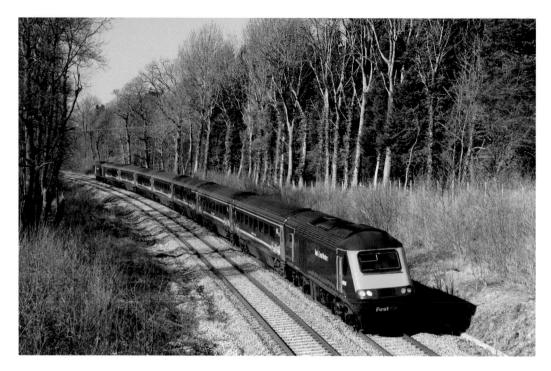

Mickleton

Mickleton, to the north of the 887-yard Campden Tunnel, was the site of a short-lived halt that had been opened in November 1937 and closed in October 1941. These two recent photographs, both taken by Martin Loader, show HSTs approaching the site of the halt. The lower view, taken in 2009, shows preliminary work in progress in connection with the re-doubling of the line, the tractor being employed in vegetation clearance; the train was led by power car No. 43024.

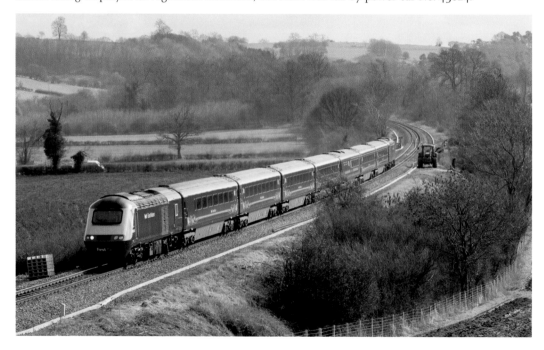

Honeybourne: Outline History

Honeybourne (38 miles 15 chains) was opened in 1853 as one of the original stations on the OW&WR route, but it did not become a junction until the opening of the Stratford-upon-Avon branch on 12 July 1859. The Stratford branch was subsequently upgraded to form part of a new main line between Cheltenham and Birmingham, and in its fully developed form Honeybourne became an important rural junction with four platform faces for main line and local traffic. The four platforms were linked by a plate girder footbridge, and the station was equipped with a range of standard GWR brick buildings, the main block being a hip-roofed structure on the down main line platform.

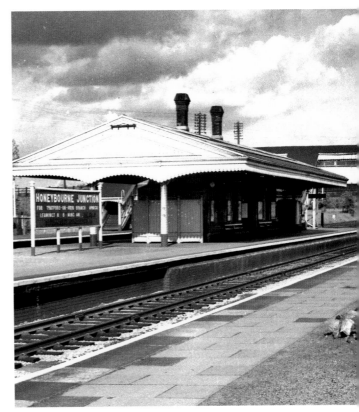

The platforms were numbered in logical sequence from one to four: Platform One was the down main platform; Platforms Two and Three were the two sides of a central island platform; and Platform Four was the outer platform on the northern side of the station.

The junction arrangements incorporated a triangle, with one arm extending north-east in the direction of Birmingham, while the other curved south-east through a full 90 degree turn in order to allow through running between Stratford and Oxford. Another curve enabled trains to run into the station from the Cheltenham direction.

Having been severely downgraded in January 1966, Honeybourne station was closed in May 1969. However, following a successful two-year campaign, the station was reopened on 22 May 1981.

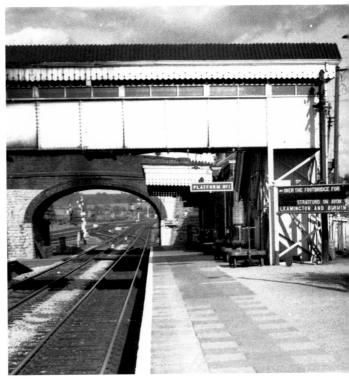

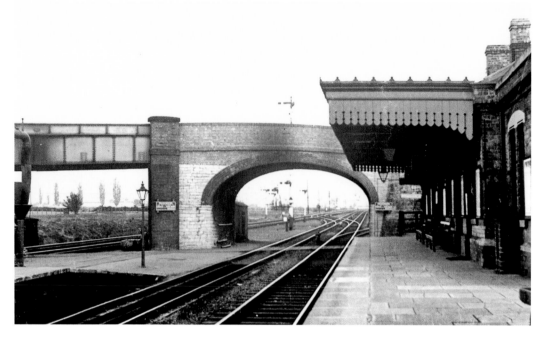

Honeybourne: The Station Buildings

The upper view provides a glimpse of the down-side station building on Platform One, looking east towards Oxford during the 1960s. This typical GWR structure contained the usual booking office and waiting room facilities, together with a porter's room, stationmaster's office and toilets for both sexes. The lower photograph shows the subsidiary building on the island platform, which contained additional toilets and waiting room accommodation; the photograph, from an Edwardian postcard, is looking west in the direction of Worcester.

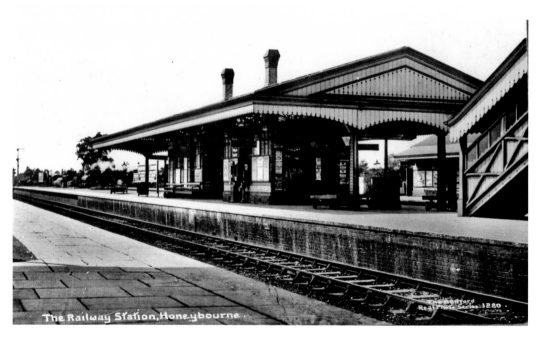

The Railway Station, Honeybourne.

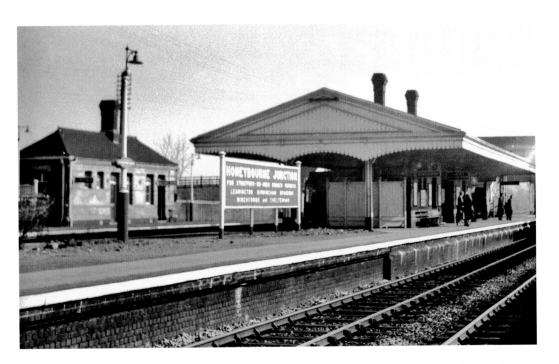

Honeybourne: Run-Down of the Cheltenham & Honeybourne Line

Above: A further view of the island platform, looking east towards Oxford, with the waiting room on Platform Four visible to the left of the picture. *Right*: A Collett '48XX' class 0-4-2T stands in Platform Four with a local passenger working, which is waiting to depart for Cheltenham.

Most local passenger services between Cheltenham and Honeybourne were withdrawn in March 1960, leaving a residual service between Cheltenham, Stratford and Leamington, which survived until 1968. The Cheltenham & Honeybourne line remained open for freight and diversionary traffic until 1976, when a section of track was badly damaged by a derailed freight train. The Honeybourne to Stratford-upon-Avon section lingered on until 1969, when it too was closed, although the line remained open for goods traffic in connection with the Army depot at Long Marston.

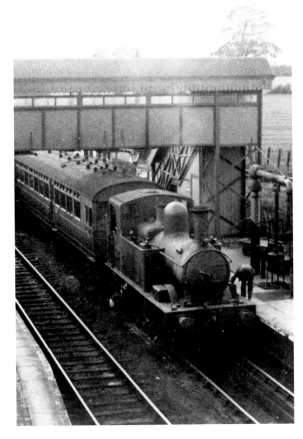

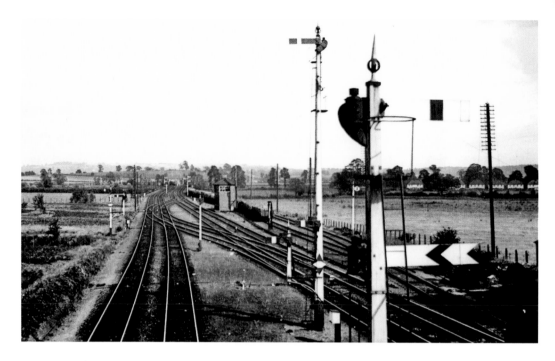

Honeybourne

This panoramic view shows the eastern approaches to the station, looking towards Oxford during the 1960s – the up and down main lines can be seen to the right. The lower view, in contrast, shows No. 47853 *Rail Express* rejoining the main line at Honeybourne with the 12.35 Long Marston to Chaddesden working, conveying a rake of wagons removed from storage on 23 January 2007. The track layout has obviously been much simplified in the intervening years.

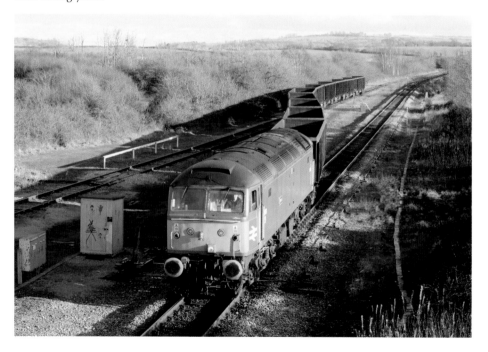

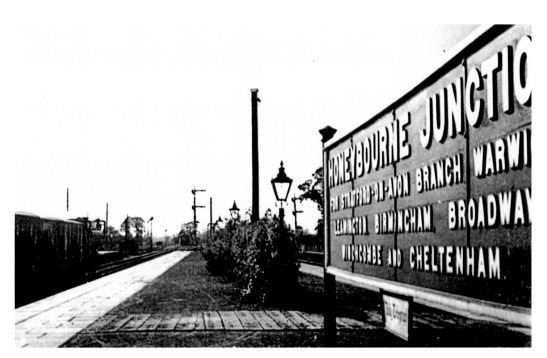

Honeybourne: Signalling and Miscellaneous Details

The upper view shows one of Honeybourne's station nameboards, which spelled out a range of destinations including Stratford-on-Avon, Warwick, Leamington Spa, Birmingham, Broadway, Winchcombe and Cheltenham. The photograph to the right shows a typical Great Western lower-quadrant signal at the west end of Platform Four.

Honeybourne station issued, on average, around 15,000 tickets per annum during the 1930s; in 1930, for example, the station sold 15,074 ordinary tickets and 56 seasons, rising to 17,061 tickets and 61 seasons by 1938. Goods traffic averaged about 5,000 tons each year. It is estimated that, in 2010/11, the annual passenger usage amounted to 41,446 journeys, suggesting that the station is busier now than it was in the heyday of steam operation.

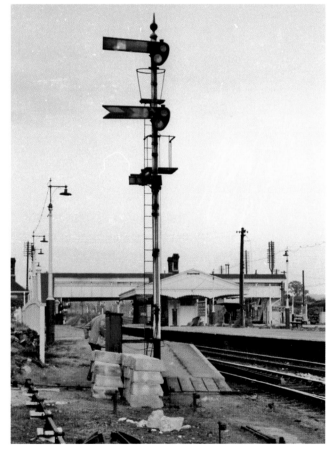

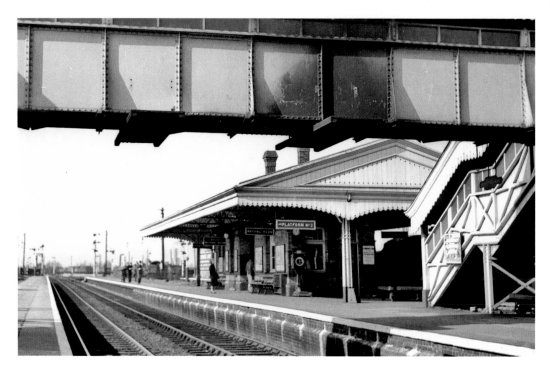

Honeybourne: Then and Now

The upper photograph provides a final glimpse of Platforms One and Two during the 1960s, whereas the colour photograph shows five-car class '180' unit No. 180110 entering the surviving platform with the 11.34 Hereford to Paddington First Great Western service on 1 November 2006. The abandoned island platform can be seen to the right, together with a pair of little-used sidings in the background. This virtually redundant trackwork is the last vestige of the once-extensive junction facilities at this rural location.

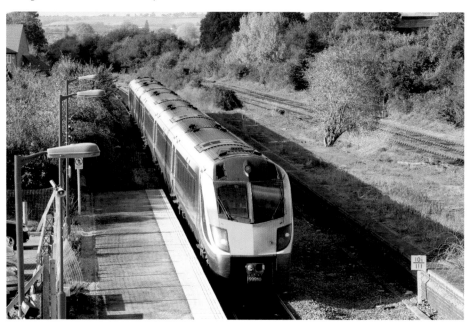

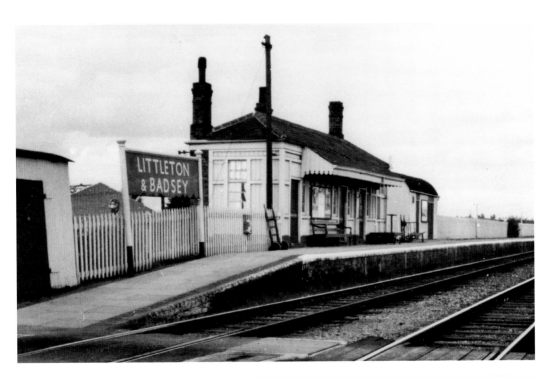

Littleton & Badsey

Continuing westwards across the Vale of Evesham, trains pass the site of the abandoned station at Littleton & Badsey. This was not one of the original OW&WR stopping places, having been opened by the GWR in 1884, and its hip-roofed, timber-framed station building reflected Great Western architectural practice. The main building was on the up platform, and there was a much smaller waiting room on the down side. Other infrastructure here included a level crossing, a signal box and a goods yard.

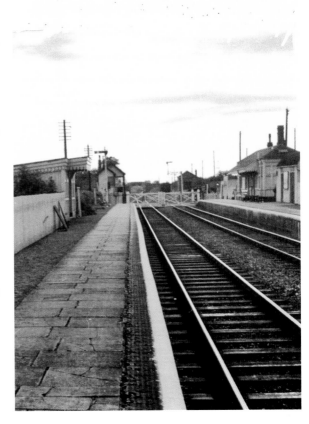

Generally speaking, the smaller stations on the 'Cotswold line' handled, on average, around 10,000 passengers a year during the early twentieth century. Littleton & Badsey, for example, booked 10,514 tickets in 1903, falling to 8,034 by 1930; in that same year, freight traffic amounted to 21,908 tons. Littleton & Badsey was closed on Saturday 1 January 1966; its buildings were subsequently demolished.

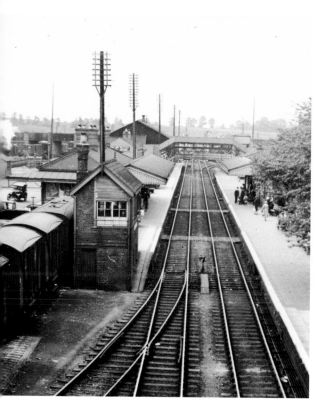

Evesham: Great Western & Midland Stations

Speeding westwards across the fruit and vegetable growing district of the Vale of Evesham, trains soon reach Evesham, 43 miles 15 chains from Oxford. The station is preceded by a dismantled girder bridge that once carried the Midland Railway line from Barnt Green to Ashchurch over the Oxford, Worcester & Wolverhampton route. Prior to the closure of the ex-Midland line in 1962, the two lines had run parallel towards their respective stations, the Midland station being on the south side of the OW&WR main line.

The upper picture, taken from the road overbridge, shows the GWR station in the 1930s; whereas the lower view was photographed from the front seats of a class '117' DMU in 1972. The Great Western station has two platforms, which are linked by a lattice-girder footbridge.

The Midland station at Evesham consisted of up and down platforms, with the station building on the up side. The latter structure was a 'hall-and-cross-wings' design, with a central booking hall and two cross wings. The building was constructed of red brick, with arched window surrounds and a glazed canopy on the platform side. The Great Western and Midland stations were sited within a few yards of each other, and indeed they shared a common approach road. It was, therefore, entirely logical that they were eventually treated as a single station, which was placed under the control of the LMS stationmaster as part of a programme of rationalisation that was carried out in the 1930s.

The combined stations were well equipped with sidings and goods-loading facilities. The original OW&WR goods yard had been situated to the north of the platforms on the down side, but around 1931 a new and more spacious goods yard was laid out on a new site north-west of the passenger station. This has now been closed, although one short siding has been retained for engineering purposes.

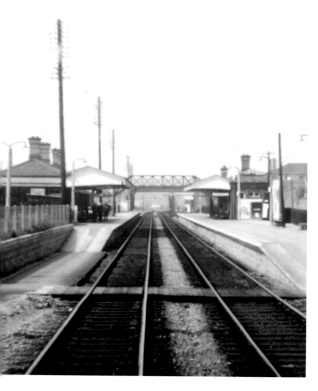

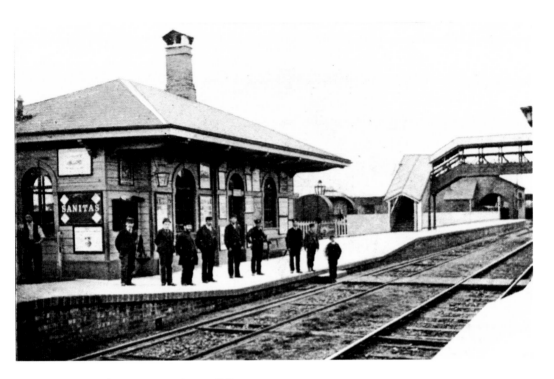

Evesham: Old & New Station Buildings

When opened in 1852 Evesham had been regarded as one of the principal intermediate stations on the OW&WR system and, for this reason, it was provided with a Brunelian 'chalet' type station building, which is illustrated above. This wooden building eventually became inadequate in relation to the traffic that it was called upon to handle, and it was therefore replaced by a standard GWR station building, as shown in the lower view, which was taken from a 1970s colour slide.

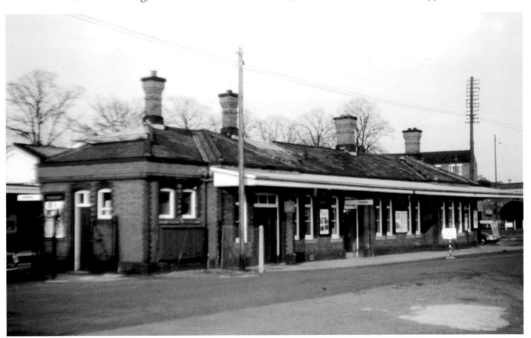

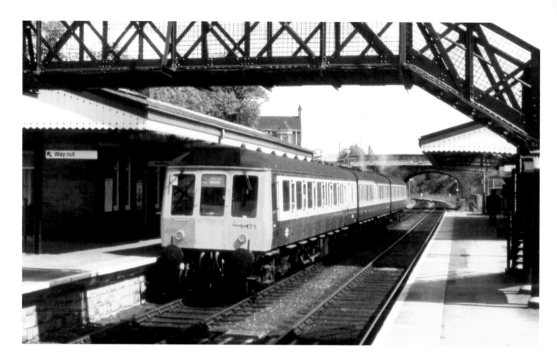

Evesham

The view above shows the up side of the station in 1997, with a class '117' three-car unit neatly framed by the footbridge. The lower view, dating from May 1955, provides a glimpse of the neighbouring Midland station, which adjoined the Great Western station. In later years, the ex-Midland platforms were numbered 1 and 2, while the GWR platforms were designated platforms 3 and 4. The Midland station building is now used as an office block. *Inset*: A British Railways first-class single ticket from Evesham to Paddington, issued on 17 June 1970.

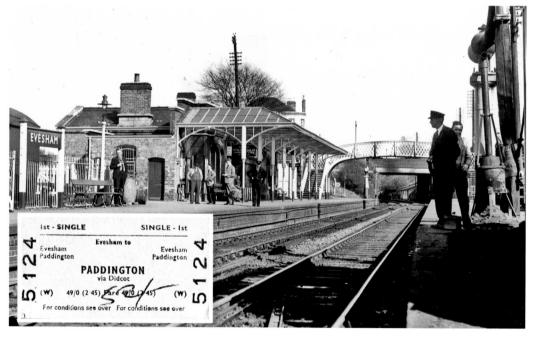

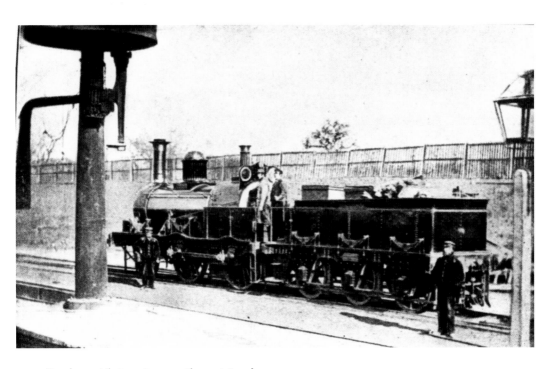

Evesham: Vintage Locomotives at Evesham

Above: A Wilson '21' class 2-4-0 poses for the camera at Evesham in 1863; there were, in all, six of these locomotives, together with two similar engines with larger wheels (see page 5). *Below*: A Great Western 'Achilles' class 4-2-2 single-wheeler pauses at Evesham with a down express. Six of these handsome locomotives were stationed at Worcester in 1910, including Nos 3027 *Worcester*, 3045 *Hirondelle*, 3050 *Royal Sovereign*, 3056 *Wilkinson*, 3059 *John W. Wilson* and 3060 *John G. Griffiths*.

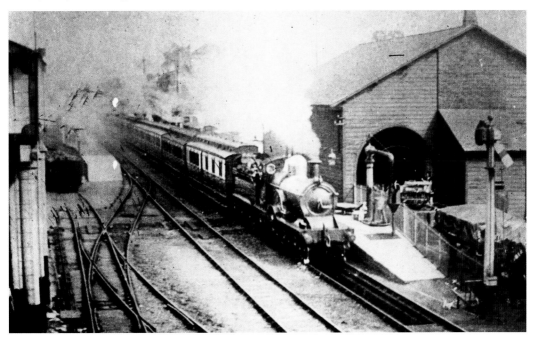

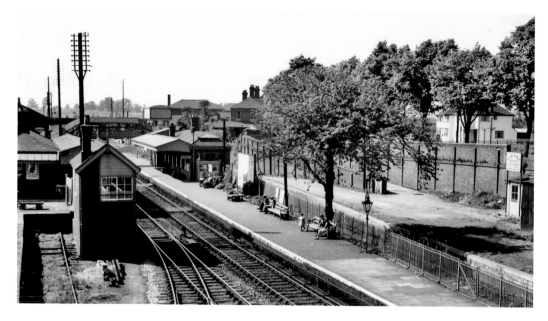

Evesham

The upper view probably dates from around 1930, before the construction of the new goods yard. The south signal box, which was taken out of use in 1957, can be seen to the left of the picture. The colour photograph, taken by Mike Marr in May 1982, shows class '50' locomotive No. 50021 *Rodney* entering Evesham with a down train. In 1930, this station issued 62,000 tickets and handled 60,369 tons of goods, while in recent years Evesham has generated over 200,000 passenger journeys per annum.

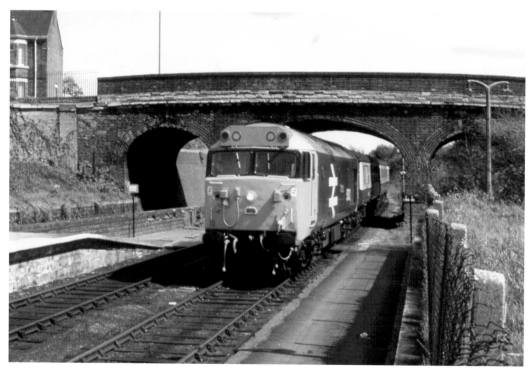

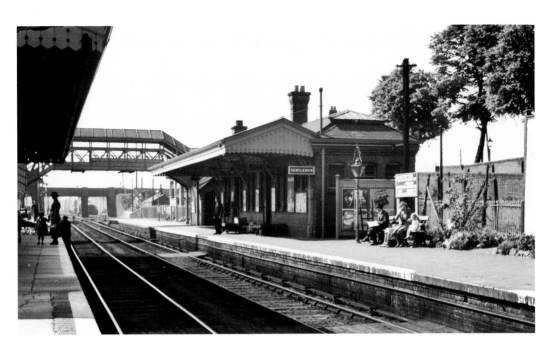

Evesham

The upper photograph provides a further 1960s view of the standard GWR buildings on the up platform. The new goods yard was situated beyond the overbridge that can be seen in the distance. *Below*: This recent photograph by Martin Loader shows class '66' locomotive No. 66090 with a loaded ballast train at Evesham. The signal box can be seen in the distance, while the short siding that can be seen to the right is a residual fragment of the 1930s goods yard.

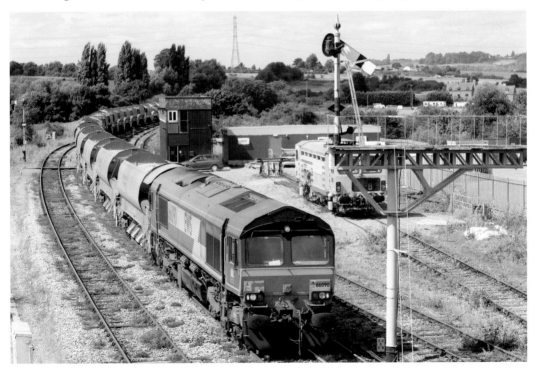

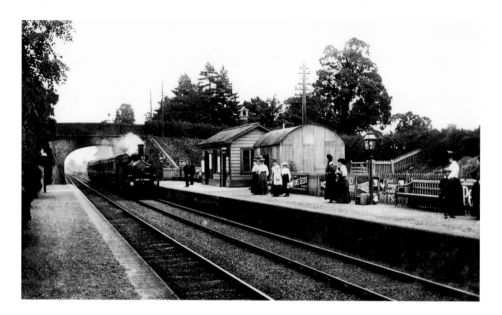

Fladbury

From Evesham: the line continues west through a more or less dead-flat landscape to Fladbury, where the station, opened in 1852 and closed in 1966, has left few traces. This now-defunct station had featured wooden OW&WR-style station buildings of the usual type, and a small goods yard. There was also a private siding that extended westwards, alongside the main line for a considerable distance before diverging south to terminate at Springhill Farm, on the Bomford estate.

'Bomford's Siding' was used for horticultural traffic – horses being used to move fruit wagons along the siding until they were eventually replaced by a tractor, which pushed the wagons along the line. The upper view shows the station during the Edwardian period, while the lower photograph was taken, looking westwards, during the 1960s. Bomford's Siding ran alongside the telegraph poles that can be seen on the extreme left of the picture.

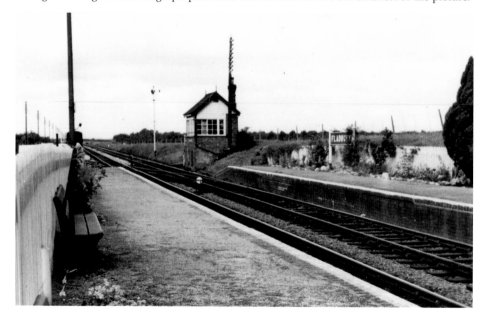

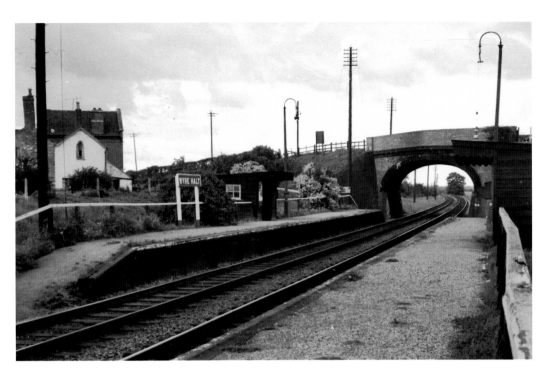

Wyre Halt

Wyre Halt, just 1½ miles further on, was opened by the GWR on 11 June 1934 to serve the adjacent village of Wyre Piddle. Its infrastructure consisted of slightly staggered earth-and-timber platforms, each of which was equipped with a small waiting shelter. These two photographs depict the halt during the early 1960s: the upper view is looking west towards the B4084 road bridge, and the lower view is looking east from the bridge. Each platform was furnished with a single nameboard and a 'gallows' type lamp-post, from which a paraffin-vapour lamp was suspended. Sadly, Wyre Halt became another victim of the 1966 purge, and few traces now remain.

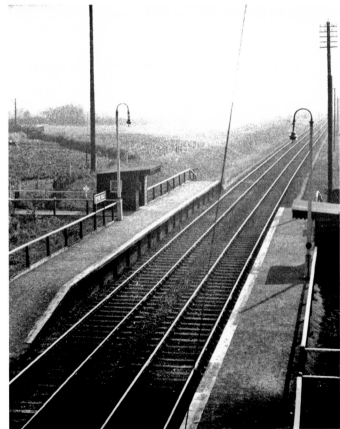

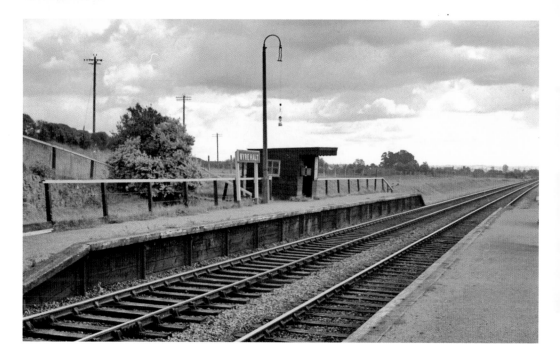

Wyre Halt

The view above shows the up platform, looking eastwards around 1964, while the recent photograph was taken by Martin Loader in 2005 between the abandoned stopping places at Fladbury and Wyre Halt. It shows class '20' locomotives Nos 20905 and 20096 hauling HST power cars Nos 43121 and 43158, and two coaches which were *en route* from the Army depot at Bicester for storage at Long Marston. *Inset*: A first-class child's ticket from Wyre Halt to Fladbury, which would have been issued by the guard.

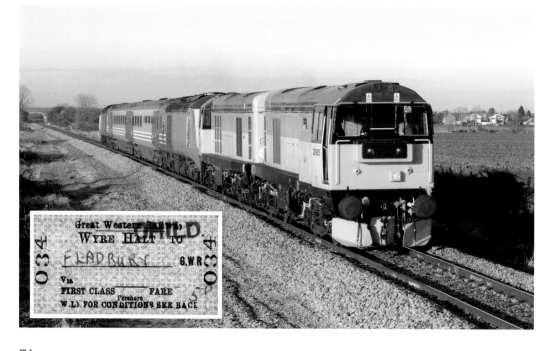

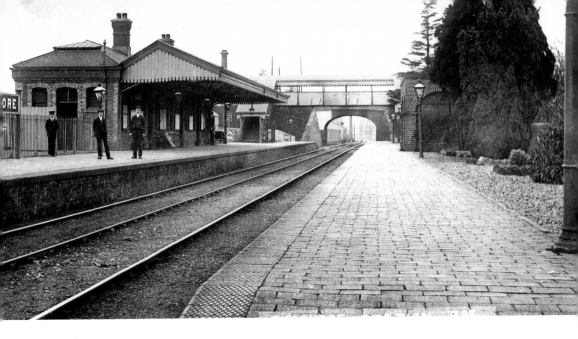

Pershore

Pershore, the only remaining station between Evesham and Worcester, is merely a shadow of its former self. In its heyday, this station boasted a standard Great Western red-brick station building on the down platform, and a waiting room of unusual design on the up side. The platforms were linked by a plate-girder footbridge, and the goods yard could handle coal, livestock, vehicles, furniture and general merchandise traffic. These two postcard views are both looking west towards Worcester, *c.* 1912.

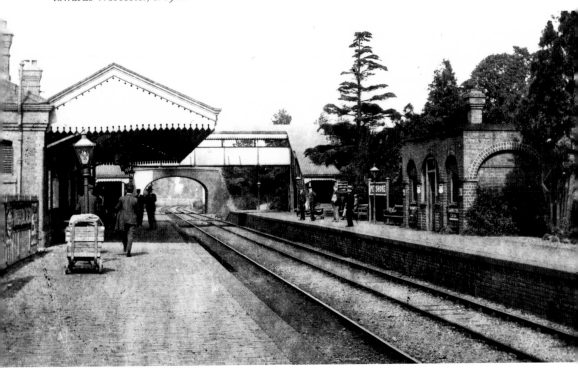

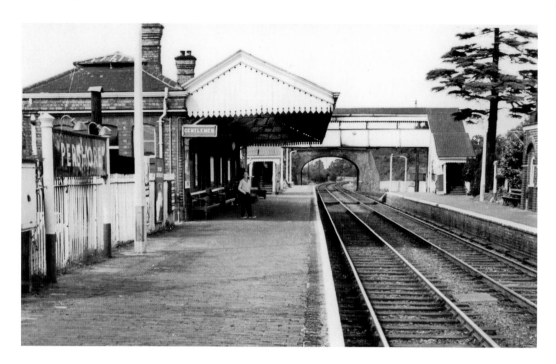

Pershore

The upper view is looking west towards Worcester during the early 1960s and the lower photograph is looking east towards Paddington, with the signal box and goods shed visible in the distance. The infrastructure here has now been reduced to the former down platform, together with a car park and two glazed platform shelters. Despite this reduction in facilities, Pershore remains a comparatively busy station; in recent years it has dealt with over 60,000 passenger journeys per annum.

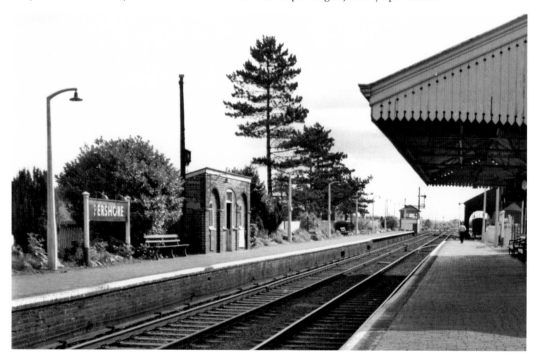

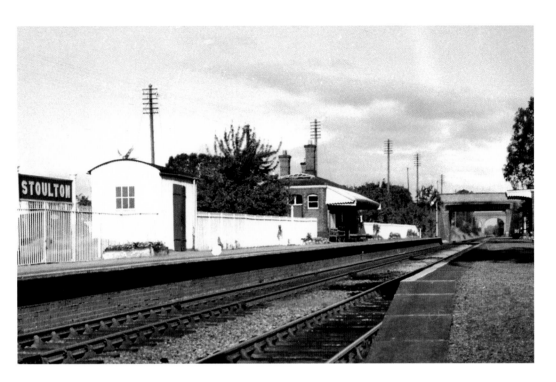

Stoulton

There were, originally, no intermediate stopping places between Pershore and Worcester, but Stoulton station was opened under Great Western auspices on 20 February 1899. It was not a particularly busy place, only 3,507 tickets being issued in 1930, falling to 2,351 in 1934; in that same year the station handled just 1,842 tons of freight. Perhaps inevitably, Stoulton became a victim of the Beeching purge, and it was closed on 1 January 1966. Little now remains.

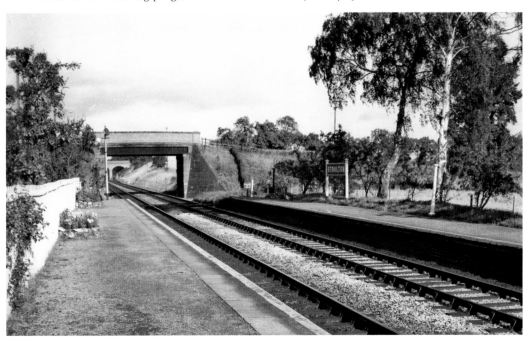

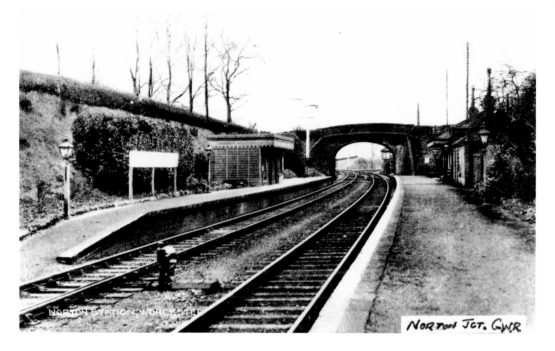

Norton Junction

From Stoulton, the line heads west-north-west to Norton Junction (53 miles 66 chains) where the OW&WR route is carried over the Birmingham & Gloucester main line before trains reach the site of Norton Junction station. A south-to-west curve is provided here to permit through running between Worcester and Cheltenham. These two east-facing views show the station around 1912, and in the 1960s; the spur to the Birmingham & Gloucester line is visible through the bridge arch.

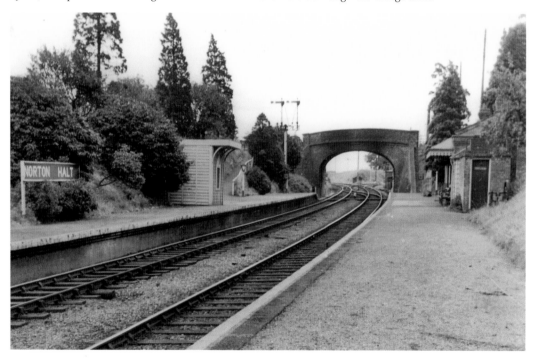

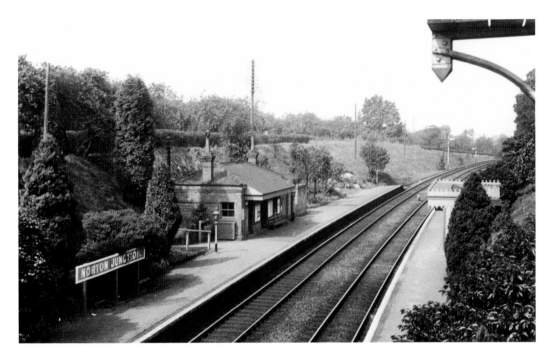

Norton Junction

The view above shows Norton Junction station from the road overbridge around 1912. This station was opened in 1879 and renamed 'Norton Halt' in 1959; it issued 12,548 tickets in 1903, falling to 6,517 by 1934. Closure took place on 1 January 1966, but the signal box, shown below, was retained to work the junction. This 1994 view shows an HST unit led by power car No. 43143 alongside Norton Junction signal box – the line to Cheltenham is visible to the right.

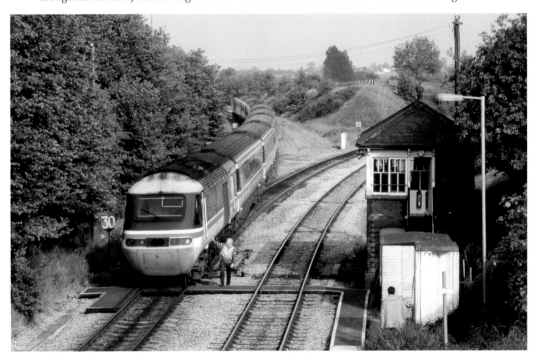

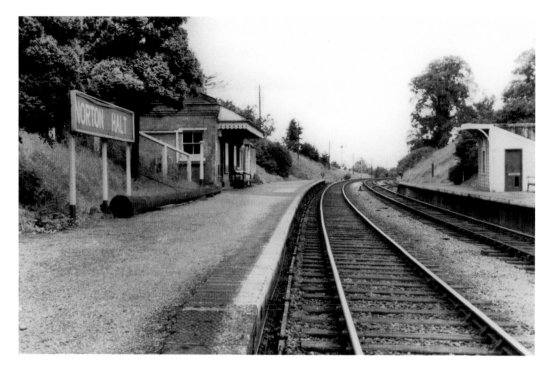

Norton Junction

The sepia view provides a further glimpse of Norton Junction station before closure, while the colour photograph, taken by Martin Loader on 20 March 2009, shows HST power car No. 43168 heading the 13.11 Hereford to Paddington First Great Western service past the site of the platforms. A class '158' unit disappears around the curve while working the 09.00 Brighton to Great Malvern service.

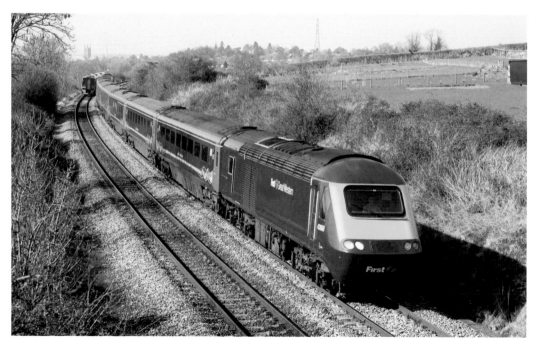

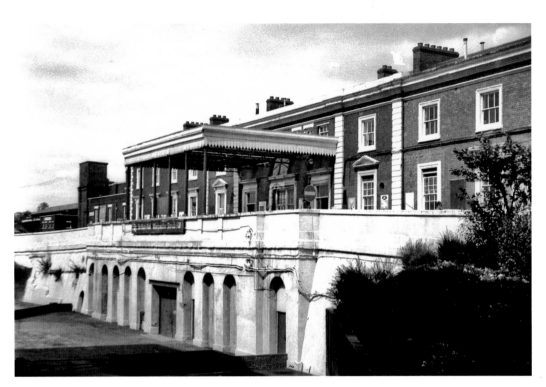

Worcester Shrub Hill

Worcester Shrub Hill, 57 miles from Oxford and 120½ miles from Paddington, is an impressive station with two-storey, classical-style buildings and a large *porte cochère*. It is of blue-brick construction with stone facings, and the whole edifice is situated upon an elevated 'basement' storey with arched apertures. It is likely that the basement had originally provided office space and other amenities – the present-day station buildings having been erected during the mid-1860s. Until that time, Shrub Hill had been the subject of much criticism; in 1858, for example, a disgruntled traveller had complained that the platform used by OW&WR trains had consisted of 'a long, narrow isolated platform, stuck like a stranded ship in the midst of the rails between the main platforms on either side'. There were 'no benches or seats of any kind', and in order to reach the island platform, passengers had to walk across the rails.

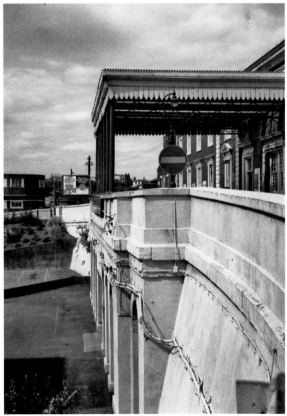

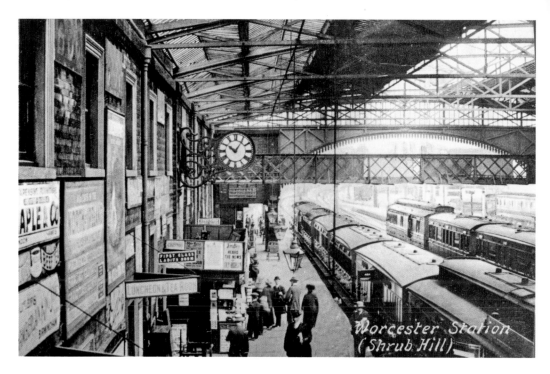

Worcester Shrub Hill

The platforms at Shrub Hill station were, at one time, covered by a cavernous overall roof, as shown in the upper picture, while in steam days, the platform lines were separated by two 'middle lines', which can be seen more clearly in the lower view. The up and down sides of the station were linked by two footbridges, one of these being the passenger footbridge, while the other was used to transfer mail and parcels across the tracks.

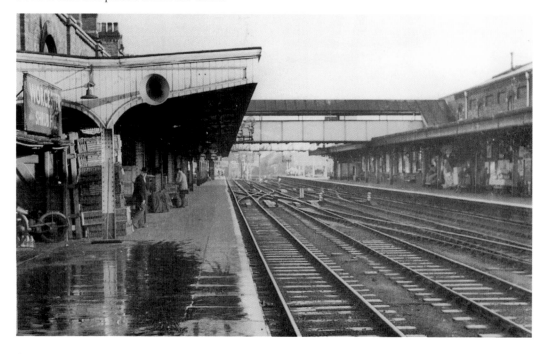

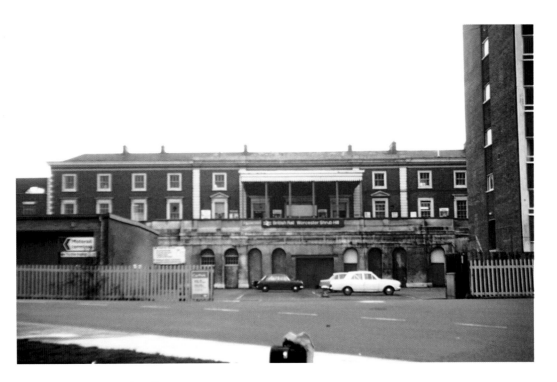

Worcester Shrub Hill

Above: A view of the main station building taken from a 1971 colour slide. The ugly modern building that can be seen to the right is an office block known as Elgar House. *Below*: This photograph, taken around 1963, is looking southwards along the down platform. The bay platform on the right was sometimes known as the Leominster bay. The 'middle roads', which can be seen to the left, were used as sidings for stabling and marshalling purposes, rather than non-stop running.

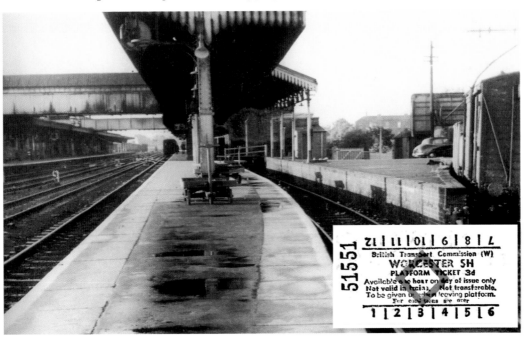

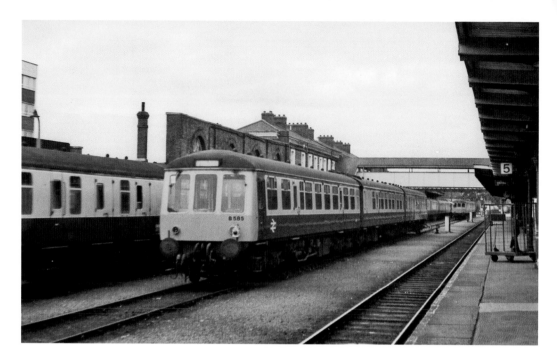

Worcester Shrub Hill

One of the two middle roads was subsequently lifted, as shown in these 1980s photographs. The upper view depicts a class '117' multiple unit in blue and grey livery on the remaining 'middle road', while the lower view shows a class '31' diesel-electric locomotive in the up platform with a Paddington express. The substantial retaining wall that once supported the overall roof can be seen in both photographs, while the obtrusive Elgar House can be seen in the background. *Inset*: A British Railways child single ticket from Shrub Hill to Foregate Street, issued on 16 February 1975.

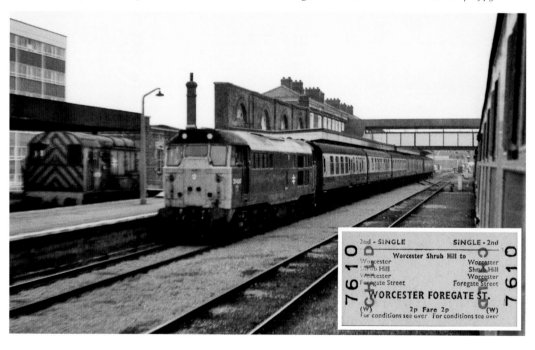

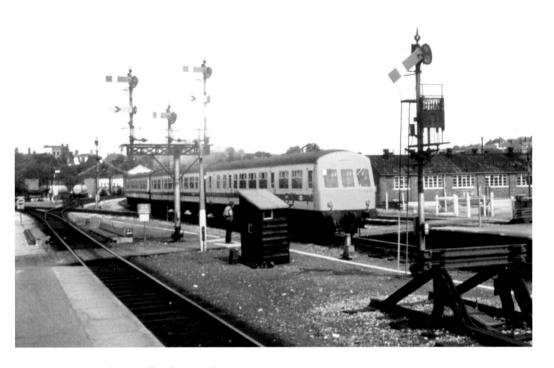

Worcester Shrub Hill: The Junctions

Above: This view from around 1979 shows a class '101' unit proceeding onto the original OW&WR route at the north end of Shrub Hill station. The Worcester & Hereford line can be seen to the left, and the engine sheds are visible in the distance. A north-to-west curve extends from Tunnel Junction to Rainbow Hill Junction, thereby forming the third arm of a triangular junction. *Below*: 'Peak' class diesel-electric locomotive No. 16 hauls a lengthy parcels train through the station, *c.* 1979.

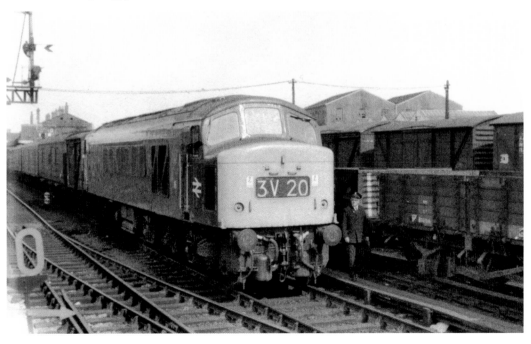

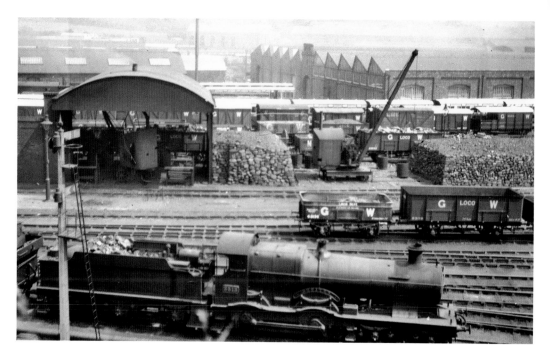

Worcester Shrub Hill: The Locomotive Sheds

Worcester's busy locomotive depot was situated within the triangle of lines to the north-west of Shrub Hill station, and a number of stabling sidings still remain at this location, although the shed buildings have been demolished. These two photographs show the shed in steam days – the sepia view having been taken around 1923, while the lower picture dates from the 1950s. The engine that can be seen in the upper view is 'Bulldog' class 4-4-0 No. 3313 *Jupiter*.

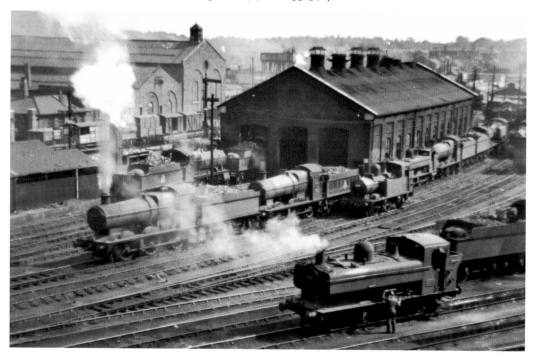

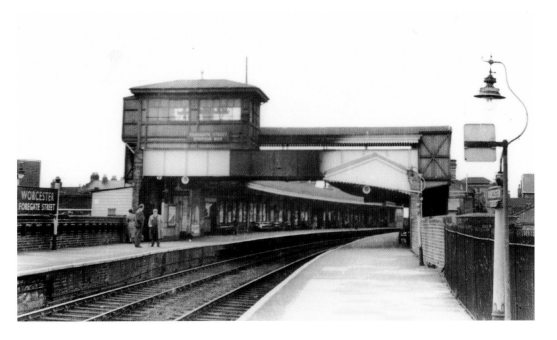

Worcester Foregate Street

As mentioned earlier, Hereford has supplanted Wolverhampton as the western end of the 'Cotswold' route, and present-day InterCity workings continue west over the Worcester & Hereford line to Worcester Foregate Street (57 miles 52 chains), where the two-platform station is situated on a lofty viaduct above the city centre. Its central position means that Foregate Street is a very busy station which, in 2010/11, generated 1,625 million passenger journeys – over twice as many as neighbouring Shrub Hill.

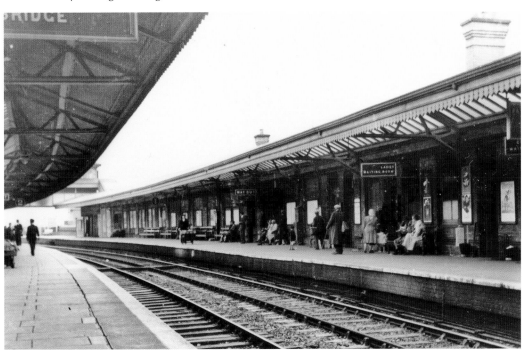

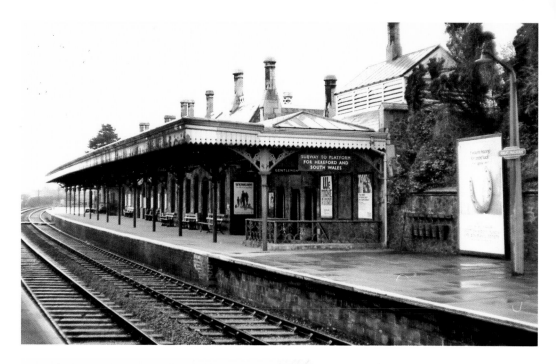

Great Malvern

Continuing westwards from Foregate Street, the Worcester & Hereford line crosses the River Severn, with excellent views to the left of Worcester Cathedral. Beyond, trains pass the sites of several closed stations and halts before reaching the still-extant stopping place at Malvern Link. This station has lost much of its Victorian infrastructure, but there is compensation at Great Malvern (65 miles 46 chains), where the fairy-tale Gothic station building has been classified as a building of historic and architectural importance.

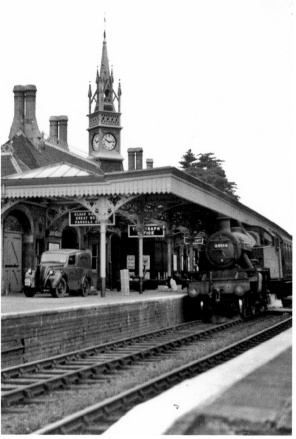

The upper view shows the main up-side station buildings in 1968, whereas the lower view is somewhat earlier, having been taken in September 1949 – at which time the sinuous clock tower was still intact. Alarmingly, this much-loved Victorian station caught fire on 11 April 1986, but a full restoration scheme was then put into effect, and the refurbished up-side building was formally reopened on 23 May 1988.

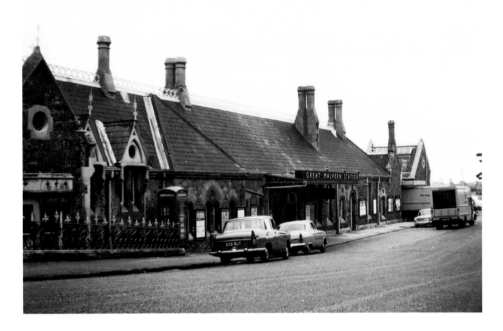

Great Malvern

This detailed study shows the rear elevation of the main up-side station building in May 1965. This elaborate structure was designed by the Victorian architect Edmund Wallace Elmslie (1819–89), who was responsible for several hotels and other buildings in the Malvern area. The lower photograph shows the down platform during the 1960s. The up and down platforms are connected by an underline subway. The facilities at Great Malvern include a *Brief Encounter*-style refreshment room known as 'Lady Foley's Tea Room'. *Inset*: A British Railways second-class single ticket from Great Malvern to Oxford, issued on 11 April 1969.

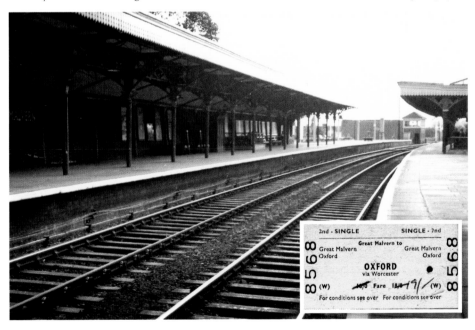

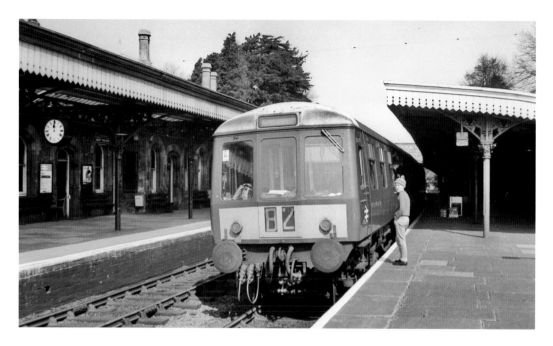

Great Malvern

Above: A Gloucester class '119' Cross Country unit stands in the down platform at Great Malvern around 1968. *Below*: Class '47' locomotive No. D1675 *Amazon* enters the down platform with a Hereford service in 1968. The large and somewhat forbidding Victorian building in the background is the former Imperial Hotel, which was purchased for use as a school by Malvern Girls' College in 1919. The hotel, designed by E. W. Elmslie, was linked to the down platform by a now derelict passage or 'covered way'.

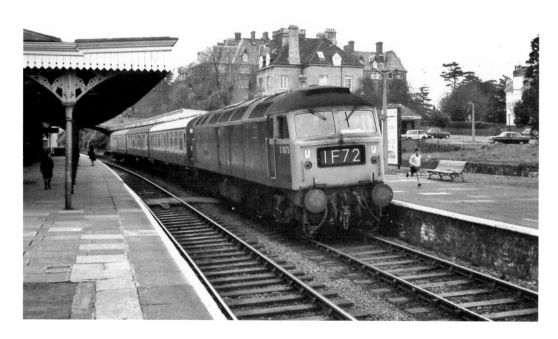

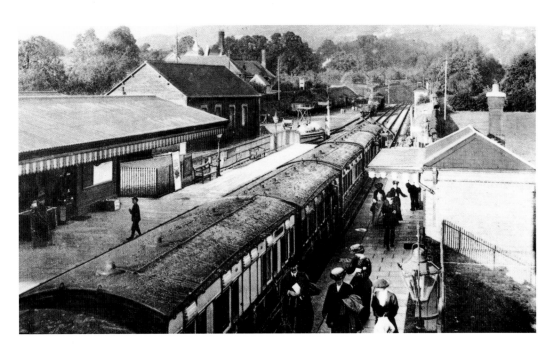

Colwall

After leaving Great Malvern, trains pass through the closed station at Malvern Wells and enter the 1,567-yard Colwall Tunnel, which takes them beneath the towering Malvern Hills. The present tunnel was opened in 1926 to replace the original bore, which is now disused. Emerging into daylight once again, westbound services enter Colwall station (68 miles 32 chains), which now has just one platform. The sepia postcard shows the station in its Edwardian heyday, while the lower view dates from around 1963.

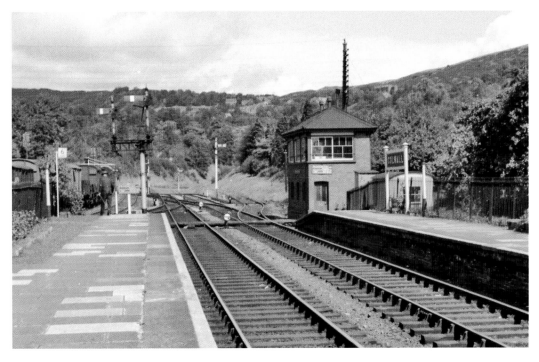

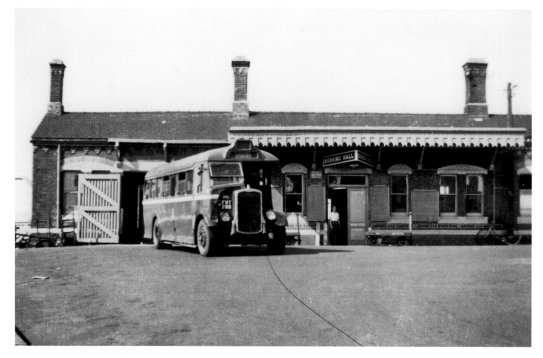

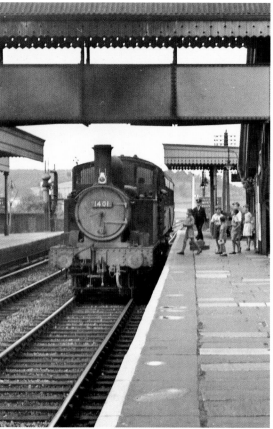

Ledbury

Ledbury station (72 miles 49 chains), which occupies a somewhat cramped site between Ledbury Tunnel and Ledbury Viaduct, once boasted a relatively complex track layout, but most of this infrastructure has now been swept away. The station was, until 1959, the junction for branch line services to Gloucester. The upper view shows the rear of the down-side station building in 1949, with Bristol Omnibus Co. bus No. 2141 in the foreground, while the lower photograph shows '14XX' class 0-4-2T No. 1401 with a Gloucester branch working.

On leaving Ledbury, westbound services run through pleasant but unspectacular countryside, passing the sites of closed stations at Ashperton, Stoke Edith and Withington. On reaching Shelwick Junction, the railway curves southwards to converge with the Shrewsbury & Hereford line and, a little under 1¾ miles further on, trains come to rest in Hereford station, 86 miles 28 chains from Oxford, and 149 miles 68 chains from Paddington.

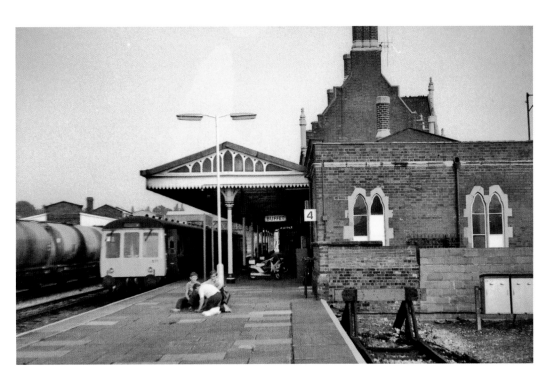

Hereford Barr's Court

Known for many years as Hereford Barr's Court, the present station was opened by the broad gauge Shrewsbury & Hereford Railway on 6 December 1853. The standard gauge Hereford, Ross & Gloucester line reached Hereford on 1 June 1855 and Barr's Court thereby became a dual-gauge station – a situation that continued for several years. The upper view shows the up platform in the early 1980s, while the colour photograph shows a class '180' unit alongside Platform One, having just arrived with a down service from Paddington. *Inset*: A British Railways third-class single ticket from Paddington to Hereford, issued on 27 May 1955.

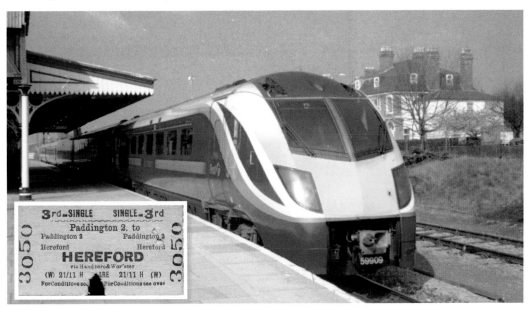

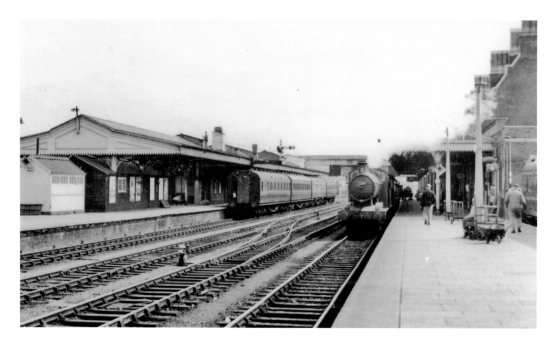

Hereford Barr's Court

Barr's Court station was remodelled during the early 1880s, and in its rebuilt form the station incorporates four platforms. The up platform on the west side has one through face and a terminal bay, whereas the down platform is an island with tracks on either side. The upper picture, dating from around 1962, is looking southwards, with a '2251' class locomotive in the up platform, while the recent view is looking northwards as a class '68' locomotive passes through the station with a freight working.

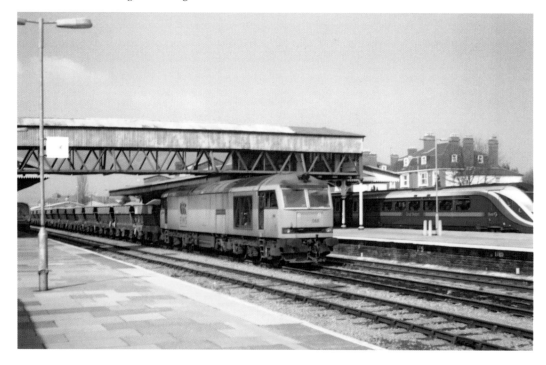

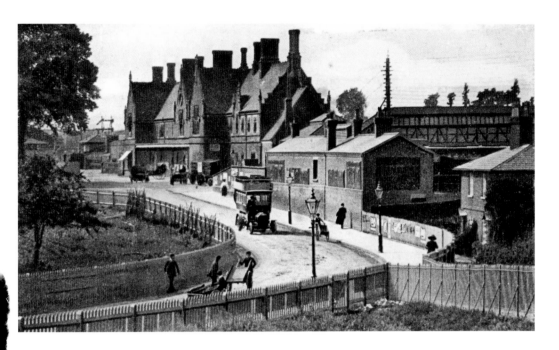

Hereford Barr's Court

The most attractive feature at Barr's Court is the ornate Tudor-Gothic style station building on the up side, which towers above the adjacent platforms – its height being accentuated by a steeply pitched gable roof and a profusion of tall chimney stacks. Designed by John Penson, the building is constructed of reddish-orange brickwork, with stone dressings, while the platform frontage was originally protected by an overall roof. The illustrations show the rear elevation around 1912 (*above*), and a century later (*below*).

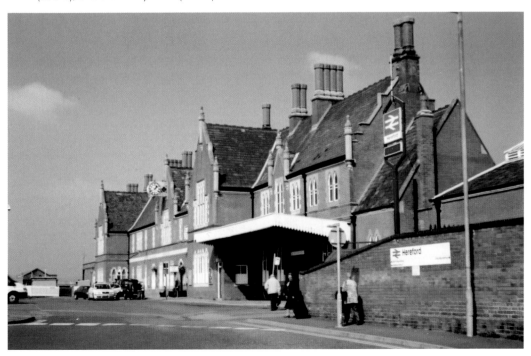

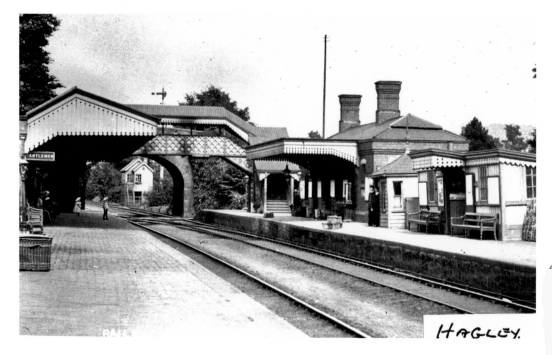

HAGLEY.

Addendum: The Northern Section of the OW&WR

Although Hereford is now the main destination for 'Cotswold line' services, the northern section of the former OW&WR route survives as far as Stourbridge as part of an important commuter link between Great Malvern, Worcester and Birmingham New Street. These two photographs depict Hagley (*above*) and Stourbridge Junction (*below*), two busy suburban stations on the 'northern section' of the Oxford, Worcester & Wolverhampton Railway.

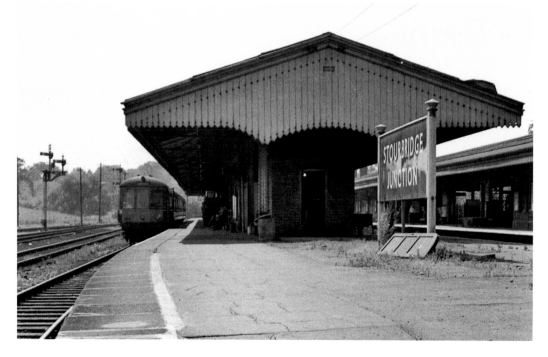